Vermont Barn Quilt
Coloring Books
John H. Lettau

Franklin County Vermont
Cover Barn Quilts
Peony Galaxy Snowball Commencement

Copyright John Lettau 2016

Franklin County Vermont Barn Quilts

A drive through Franklin County Vermont is very colorful today because many brilliant "quilt blocks," called barn quilts, are on display on barns and other structures throughout the area. Five sample barn quilt patterns located in Franklin County are pictured above...Carpenter's Wheel, Broken Wheel, Winter Stars, Buggy Wheel and Feathered Square. The idea for Barn Quilts of Franklin County was suggested by the Sheldon Raiders Homemaker's Club in 2009.

Objectives of Barn Quilt Projects

Barn quilt groups around the country try to educate, promote and celebrate the unique agricultural heritage through the visual combination of barns and quilts. Barns are vital to the economic well-being of any rural community, and the comfort of handmade quilts provide warmth, beauty, and an outlet for individual artistic expression. Projects in Vermont are based on similar projects in Ohio, Indiana, Wisconsin and the Appalachian states. Franklin County launched its own version to promote the scenic agricultural area to tourists.

What is a Barn Quilt?

A barn quilt is made by painting a quilt pattern on a ¾ inch MDO plywood square then mounting it on a barn or other outlying structure. Two coats of primer are applied to both sides of the boards and the edges. After the pattern is drawn out painter's (Frog) tape is applied. Three coats or more of each color are applied, with each coat being allowed to dry thoroughly. After the quilt is finished, it is allowed to cure for at least two weeks before it is mounted.

Making these quilt squares allows individuals and volunteer groups to create and paint their own barn square. The design that is chosen may represent a family pattern from a beloved quilt or perhaps a new pattern meaningful to the individual creator(s).

Barn Quilts of Franklin County Objectives

1. To reflect the agricultural heritage of the county
2. To be visible from the road
3. To bring pride to the area
4. To promote tourism in the county

And

Individual Objectives

5. To sharpen math and drafting skills
6. To promote creativity on a personal level

Franklin County Barn Quilt Information

franklincountyquilters.org

email at *fmercure@myfairpoint*.net

Next page find a listing of the 49 Franklin County barn quilts in this book

Barn Quilts of Franklin County Vermont

Feathered Star	Duffy Hill Rd	Enosburg
Double Sawtooth	Chimney Rd	Enosburg
Pinwheel	Tyler Branch Rd	Enosburg
Country Farm	Riley Rd	Franklin
Mariner's Compass	Rte 105	Sheldon
Farmer's Daughter	East Sheldon Rd	Sheldon
Double Monkey Wrench	Rte 105	Sheldon
Star Burst	Severance Rd	Sheldon
Ohio Star	South Maine St	Richford
Star of the East	Butternut Hollow Rd	Enosburg
Evening Star	East Sheldon Rd	Sheldon
Cornucopia	Rte 105	Sheldon
Winter Star	North Ave	Richford
Country Road	Middle Rd	Franklin
Light at the End of the Tunnel	Mill St	Sheldon
Le Moyne	Main St	Franklin
Turkey Tracks	Patton Shore	Franklin
Wheels	Richard Rd	Franklin
Double Pinwheel	East Sheldon Rd	Sheldon
Best Friend	Danyow Rd	Sheldon
Hole in the Barn	Maple Park	Enosburg
4 Point	Brown's Corner Rd	Franklin
Ohio Star	Berkshire Center Rd	Berkshire
Carpenter's Wheel	Davis Rd	Enosburg
Wheel of Fortune	Tyler Branch Rd	Enosburg
Snow Ball	Boston Post Rd	Enosburg
Maple Leaf	West Enosburg Rd	Enosburg
Bear Paw	27 Park St	Fairfield
Buggy Wheel	North Main St	Montgomery
Chained Star	South Richford Rd	Richford Rd
Broken Wheel	West Berkshire Rd	Berkshire
Windblown Lily	King Rd	Berkshire
Commencement	Corliss Rd	Richford
Peony	AA Brown Library	Richford
Friendship	Rte 105	Sheldon
Fly a Kite	Sheldon Heights	Sheldon
Galaxy	Sheldon Rd	Sheldon
Seasonal	Rte 105	Sheldon
Shooting Star	Mill St	Sheldon
Tulips	Guilmette Rd	Richford
Beagle	Guilmette Rd	Richford
Martha Washington Star	Guilmette Rd	Richford
Ribbon Cross	Liberty St Exit	Richford
Star Burst	East Sheldon Rd	Sheldon
Paddle	Patton Shore	Franklin
Eight Pointed Star	Casino Rd	Sheldon
Basket	Lost Nation Rd	Berkshire
Kansas Star	Middle Rd	Franklin

Barn Quilt Feathered Square
Franklin County Vermont

Barn Quilt Location
Duffy Hill Rd
Enosburg, Vermont

Franklin Barn Quilt Feathered Square

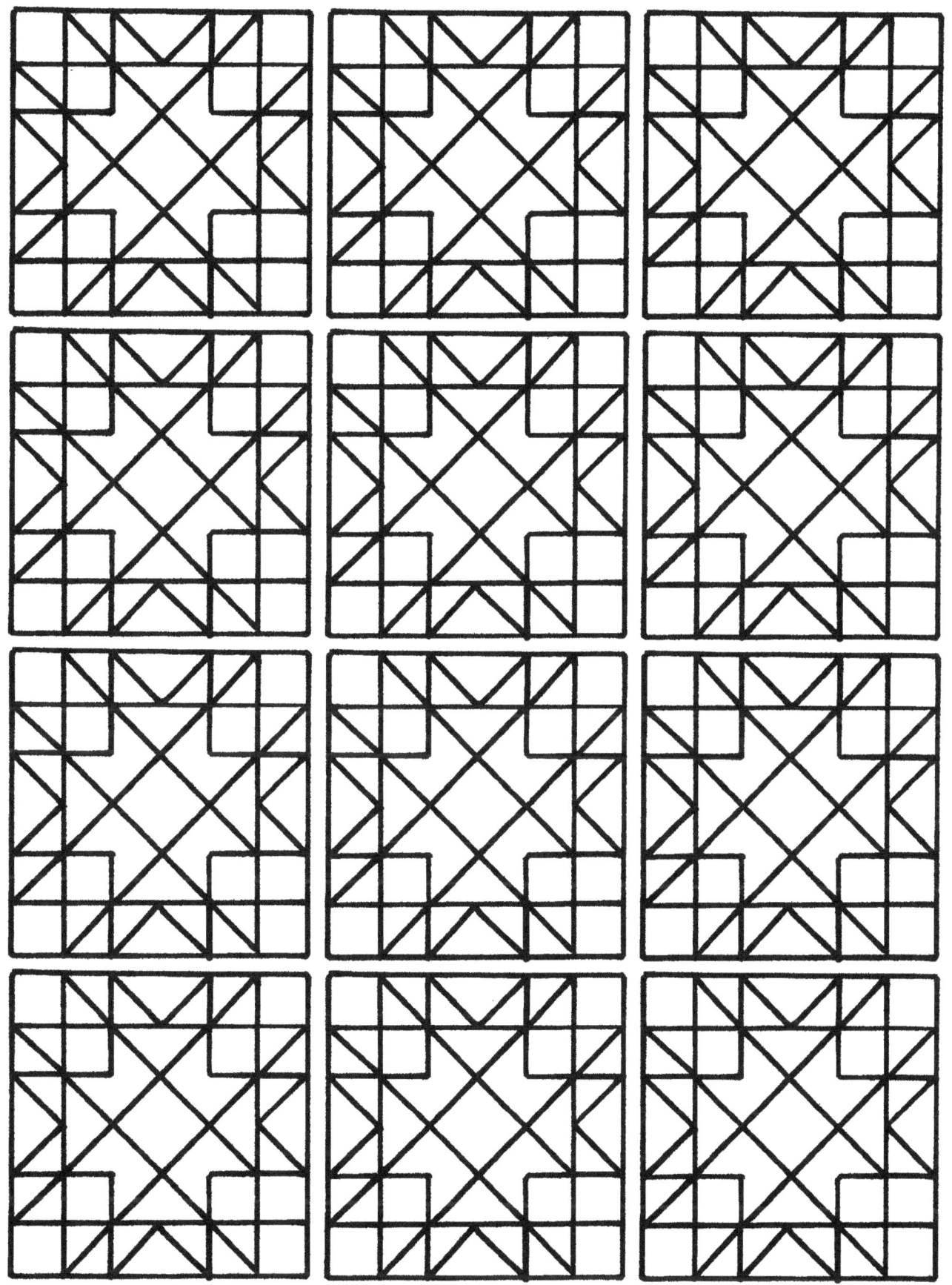

Barn Quilt Double Sawtooth
Franklin County Vermont

Barn Quilt Location
Chimney Rd
Enosburg, Vermont

Franklin Barn Quilt Double Sawtooth

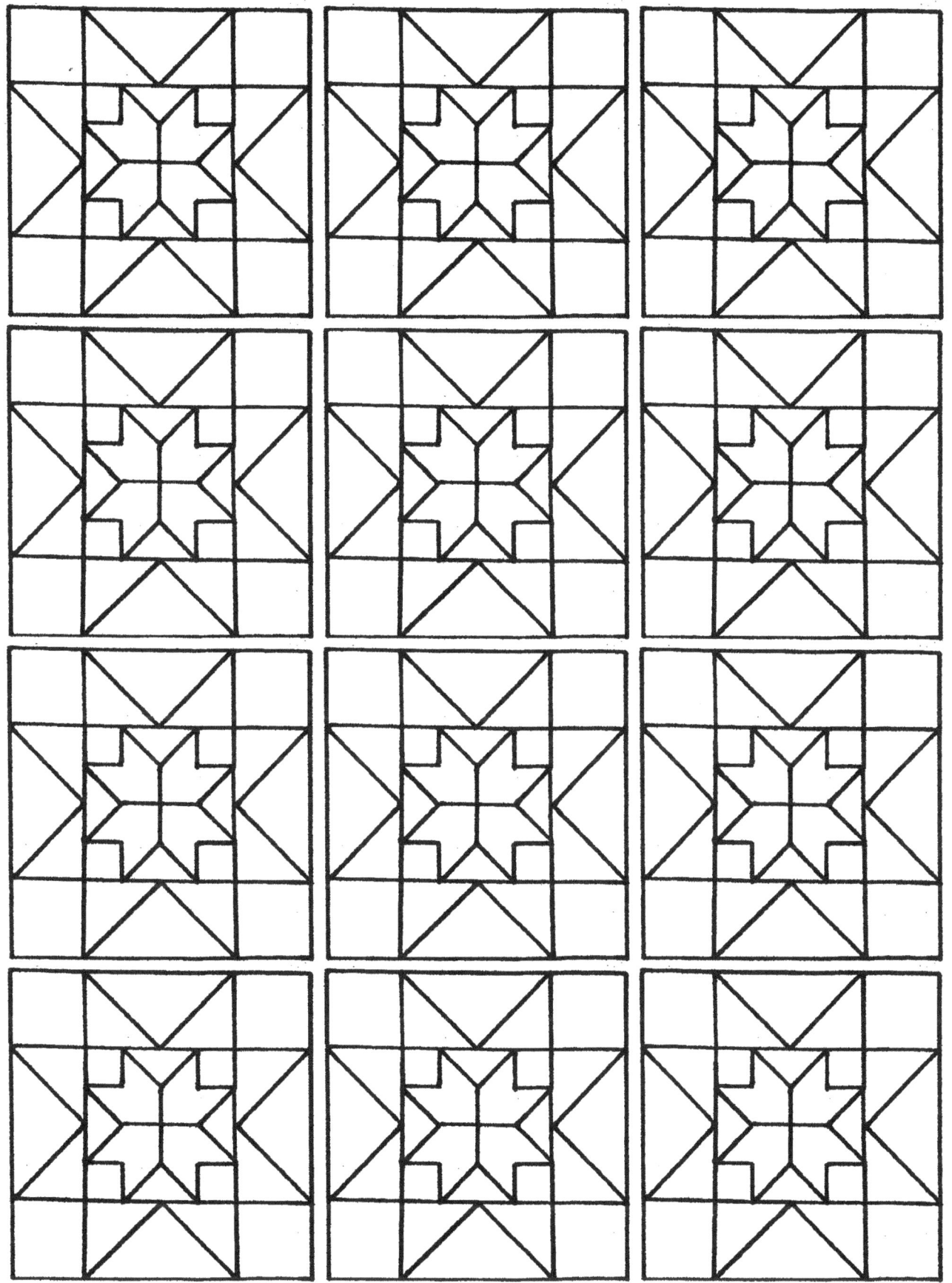

Barn Quilt Pinwheel
Franklin County Vermont

Barn Quilt Location
Tyler Branch Rd
Enosburg, Vermont

Franklin Barn Quilt Pinwheel

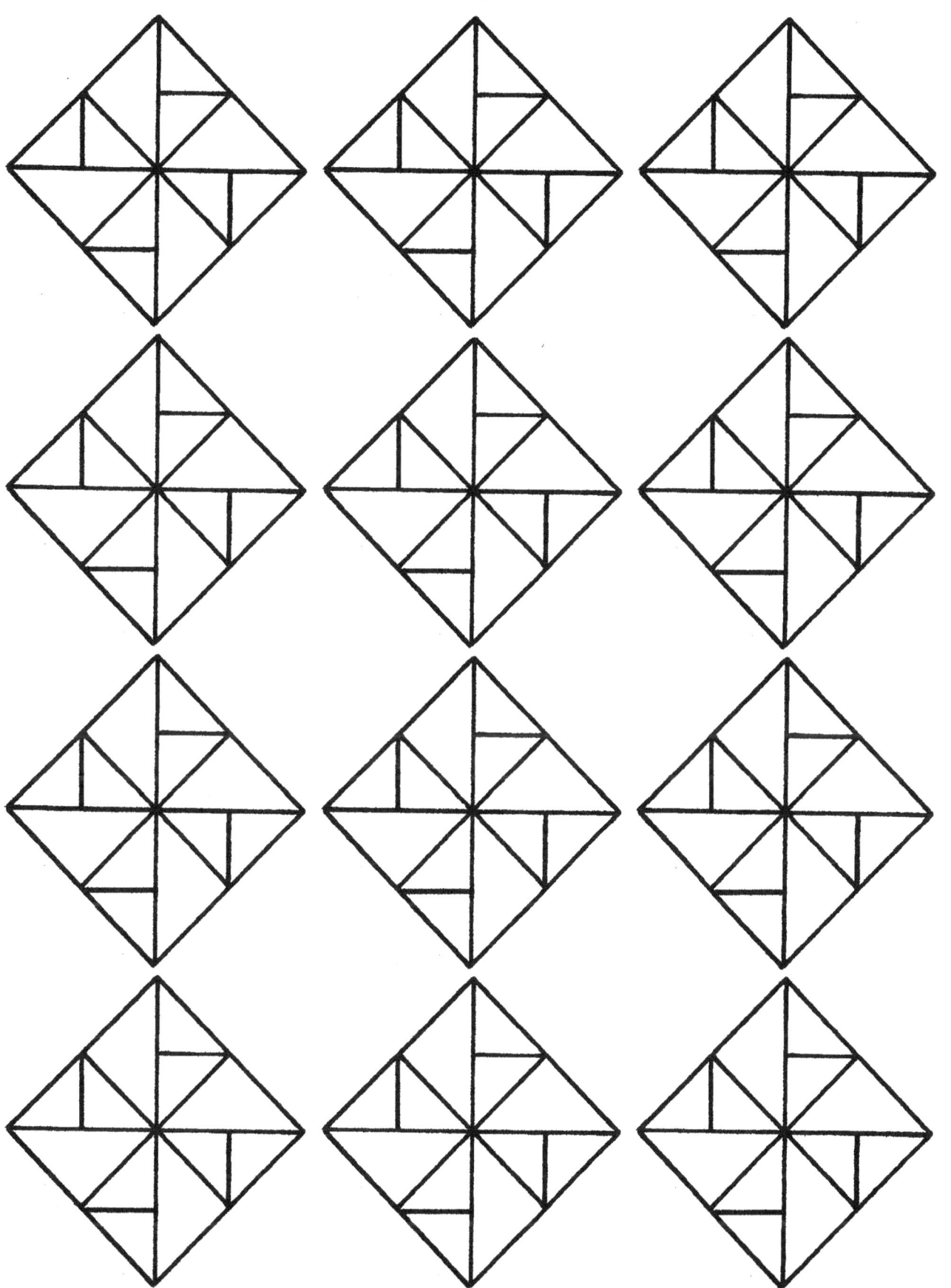

Barn Quilt Country Farm
Franklin County Vermont

Barn Quilt Location
Riley Rd
Franklin, Vermont

Franklin Barn Quilt Country Farm

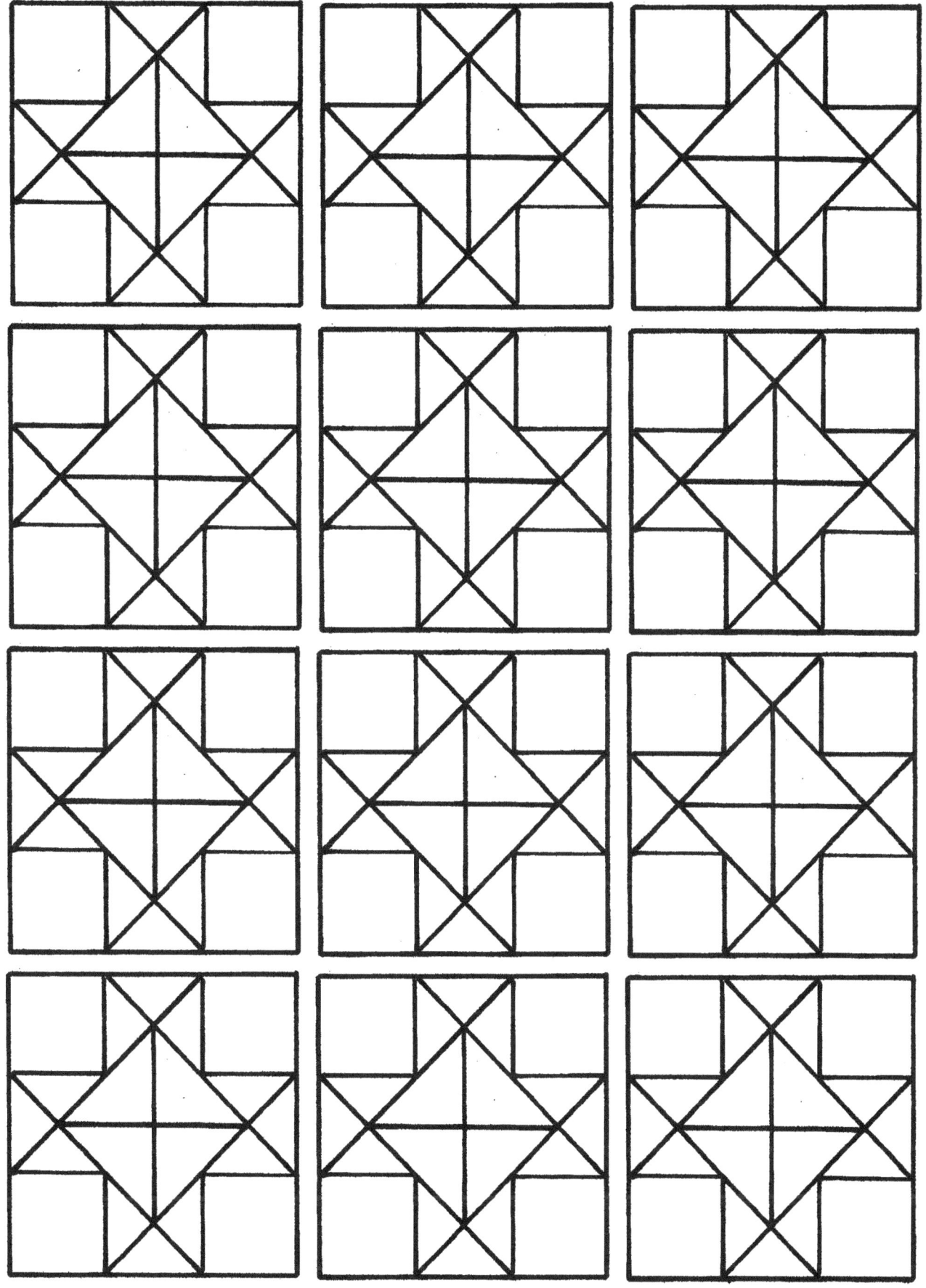

Barn Quilt Mariner's Compass
Franklin County Vermont

Barn Quilt Location
Rte 105
Sheldon, Vermont

Franklin Barn Quilt Mariner's Compass

Barn Quilt Farmer's Daughter
Franklin County Vermont

Barn Quilt Location
East Sheldon Rd
Sheldon, Vermont

Franklin Barn Quilt Farmer's Daughter

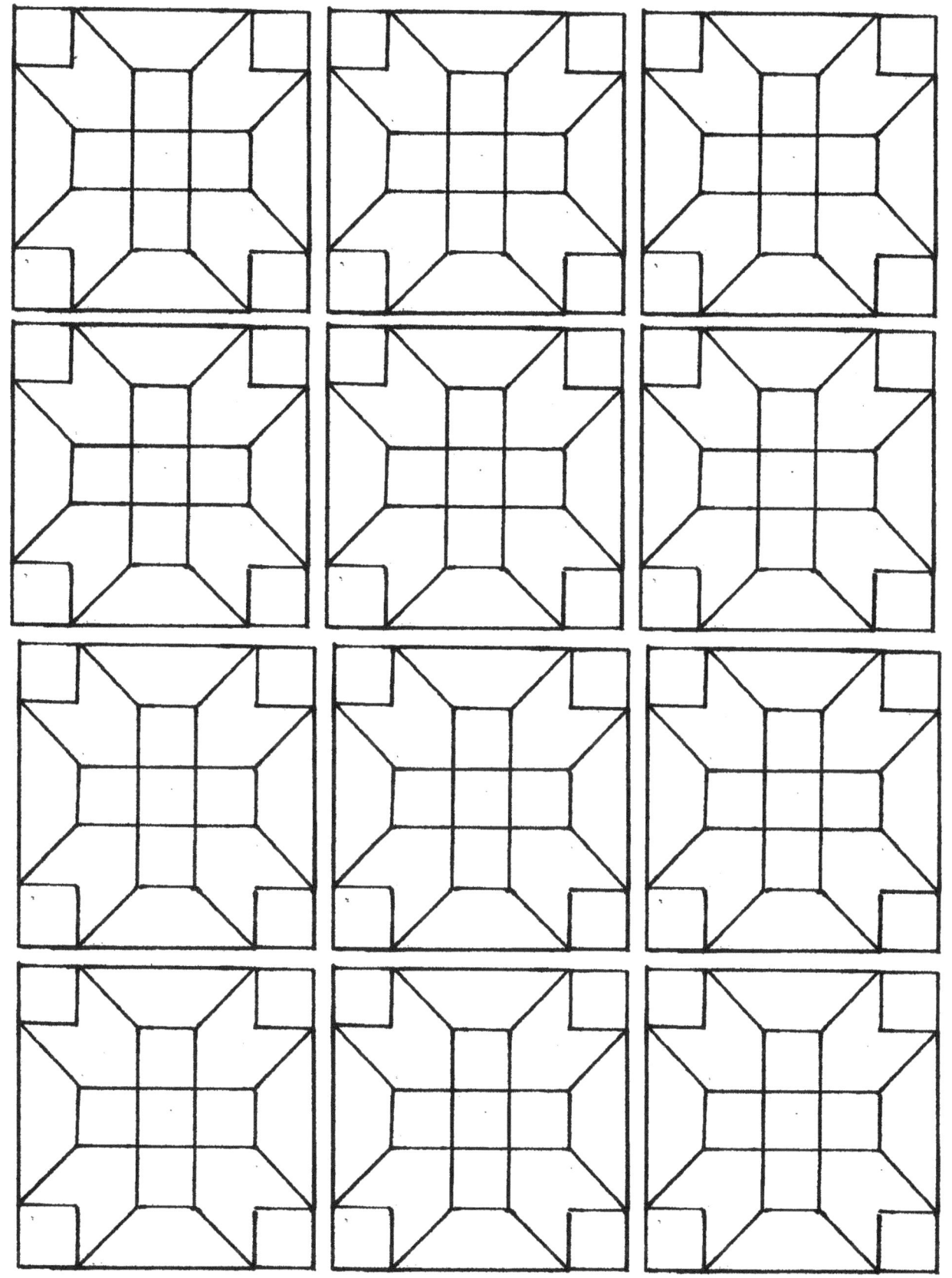

Barn Quilt Double Monkey Wrench
Franklin County Vermont

Barn Quilt Location
Rte 105
Sheldon, Vermont

Franklin Barn Quilt Double Monkey Wrench

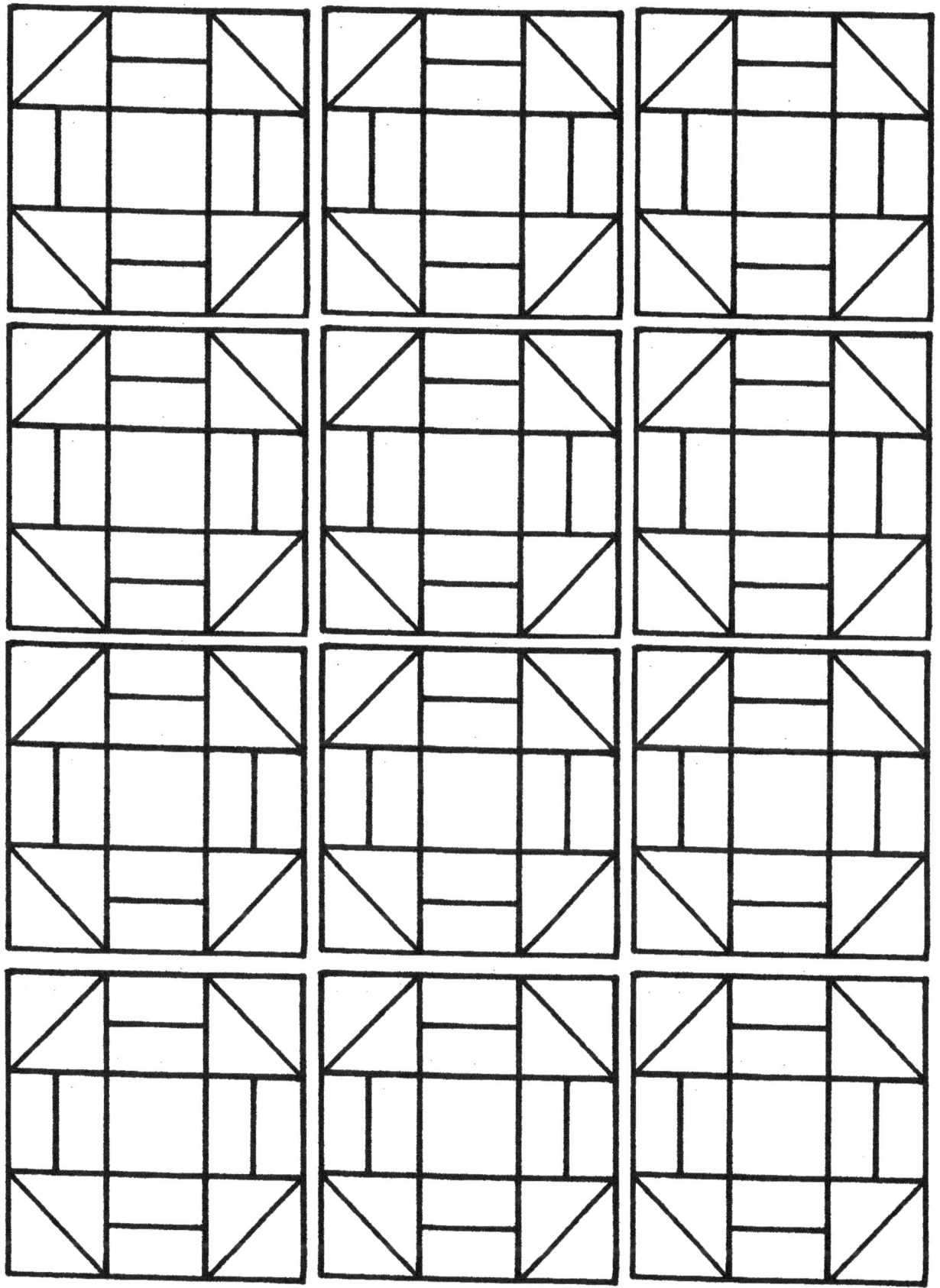

Barn Quilt Star Burst
Franklin County Vermont

Barn Quilt Location
Severance Rd
Sheldon, Vermont

Franklin Barn Quilt Star Burst

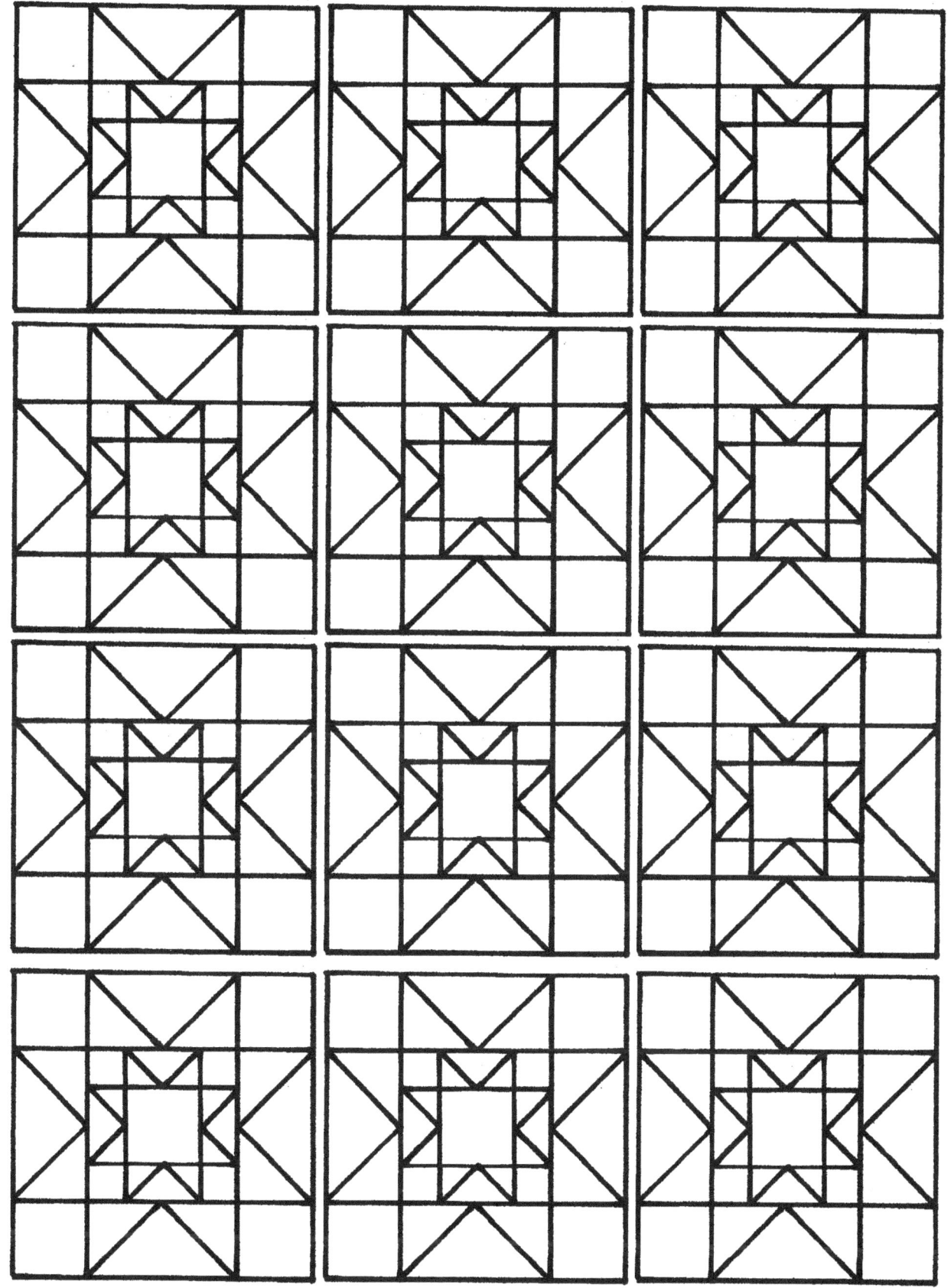

Barn Quilt Ohio Star
Franklin County Vermont

Barn Quilt Location
South Main St
Richford, Vermont

Franklin Barn Quilt Ohio Star

Barn Quilt Star of the East
Franklin County Vermont

Barn Quilt Location
Butternut Hollow Rd
Enosburg, Vermont

Franklin Barn Quilt Star of the East

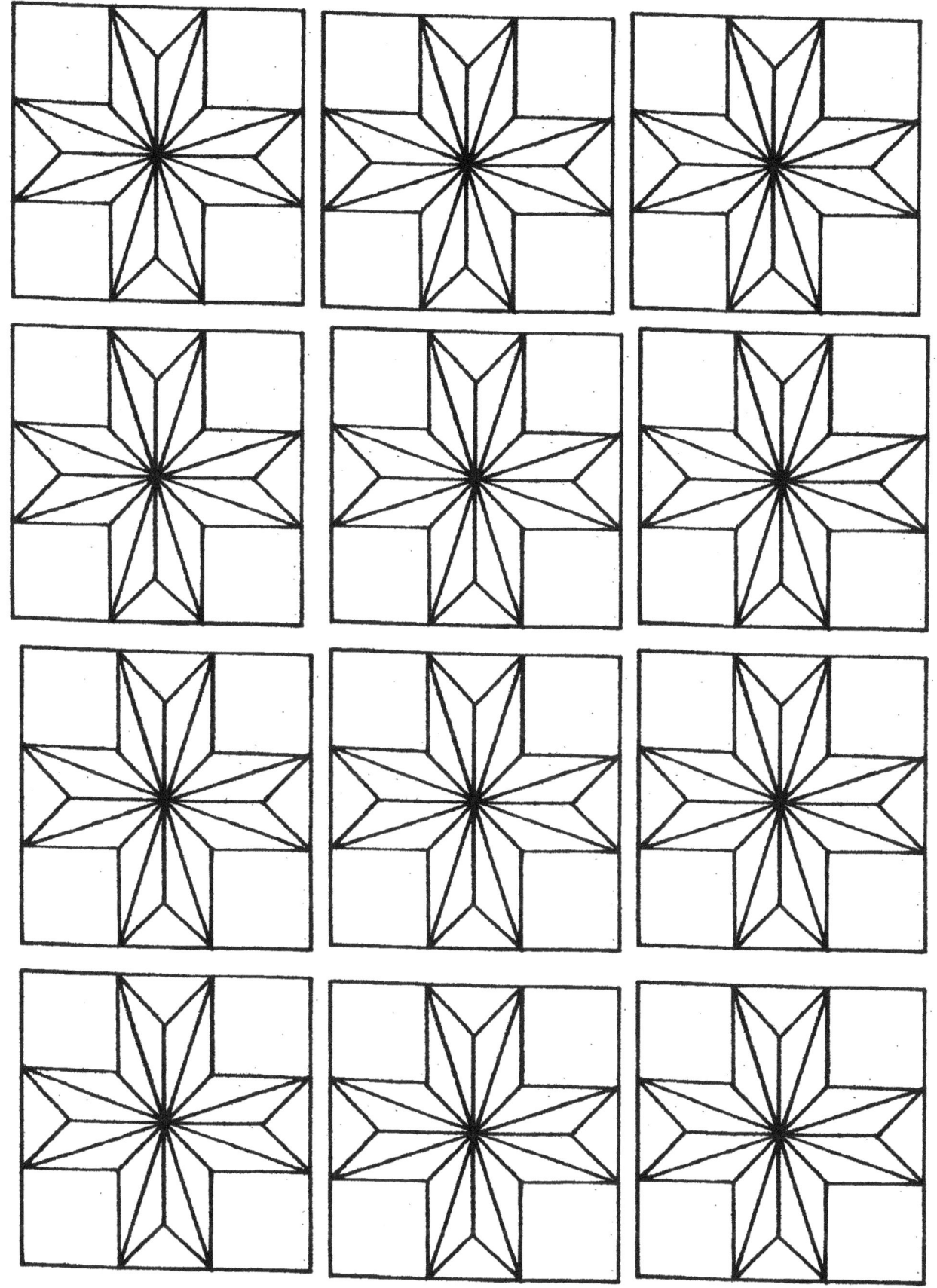

Barn Quilt Evening Star
Franklin County Vermont

Barn Quilt Location
East Sheldon Rd
Sheldon, Vermont

Franklin Barn Quilt Evening Star

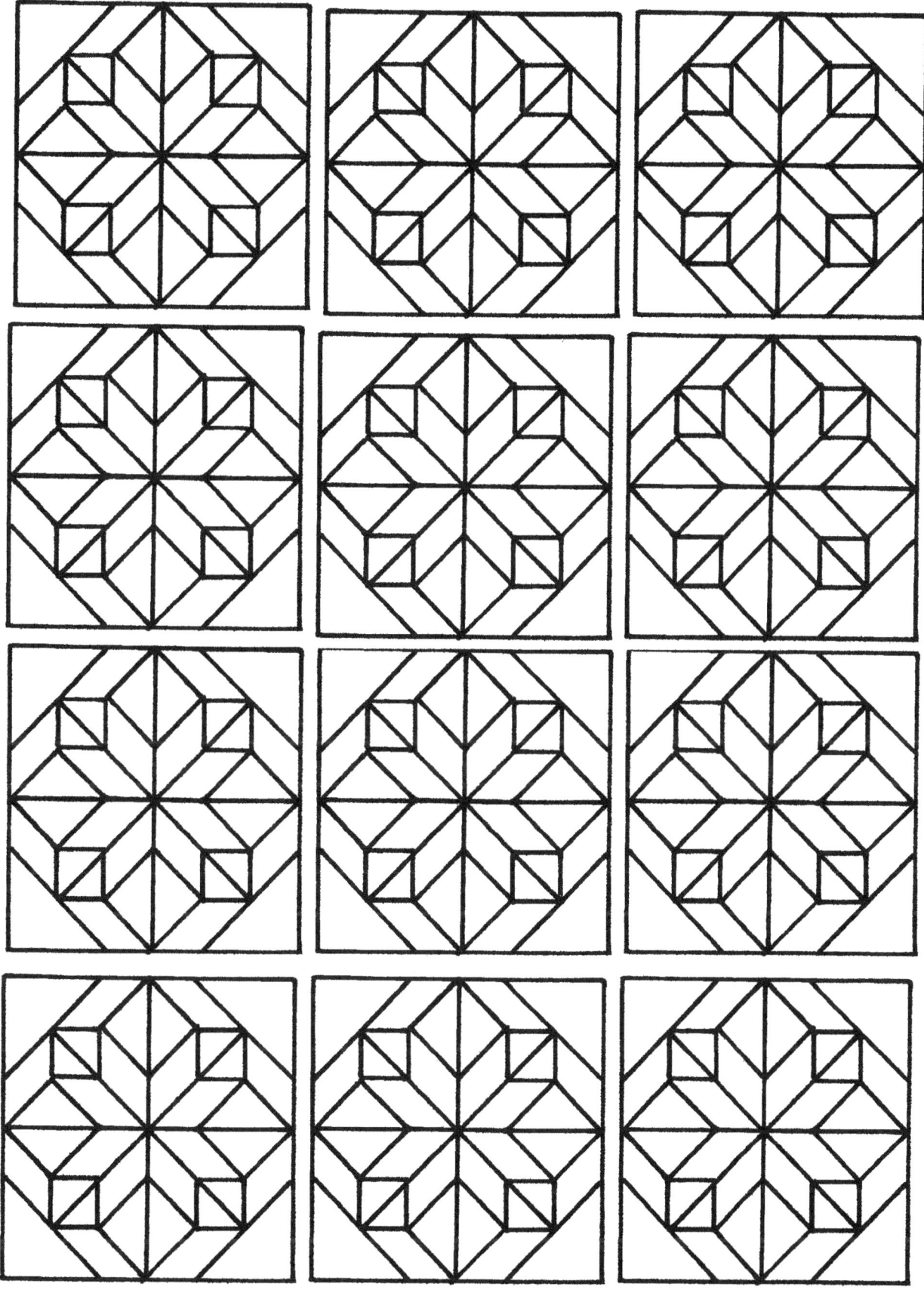

Barn Quilt Cornucopia
Franklin County Vermont

Barn Quilt Location
Vt Rte 105
Sheldon, Vermont

Franklin Barn Quilt Cornucopia

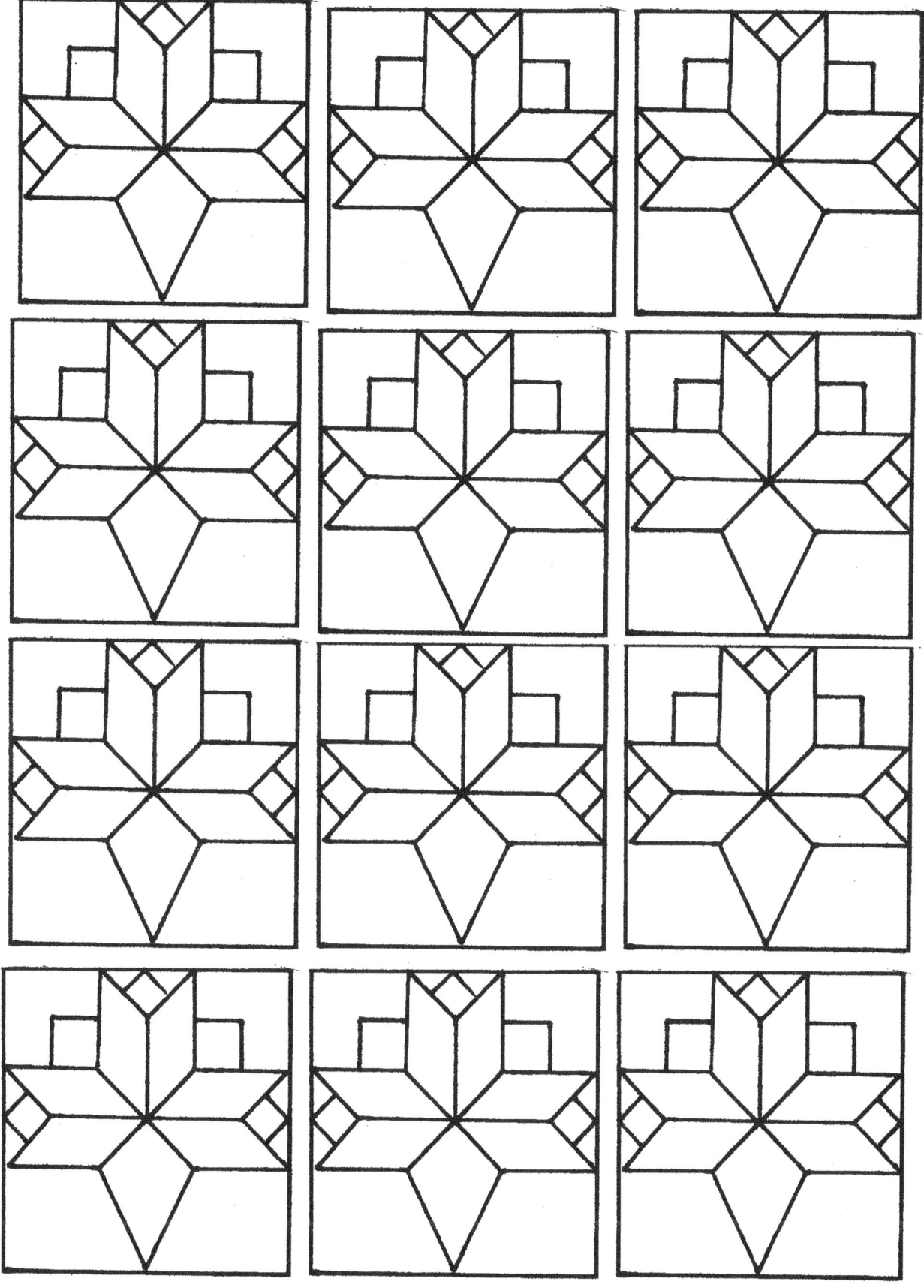

Barn Quilt Winter Stars
Franklin County Vermont

Barn Quilt Location
North Ave
Richford, Vermont

Franklin Barn Quilt Winter Stars

Barn Quilt Country Road
Franklin County Vermont

Barn Quilt Location
Middle Road
Franklin, Vermont

Franklin Barn Quilt Country Road

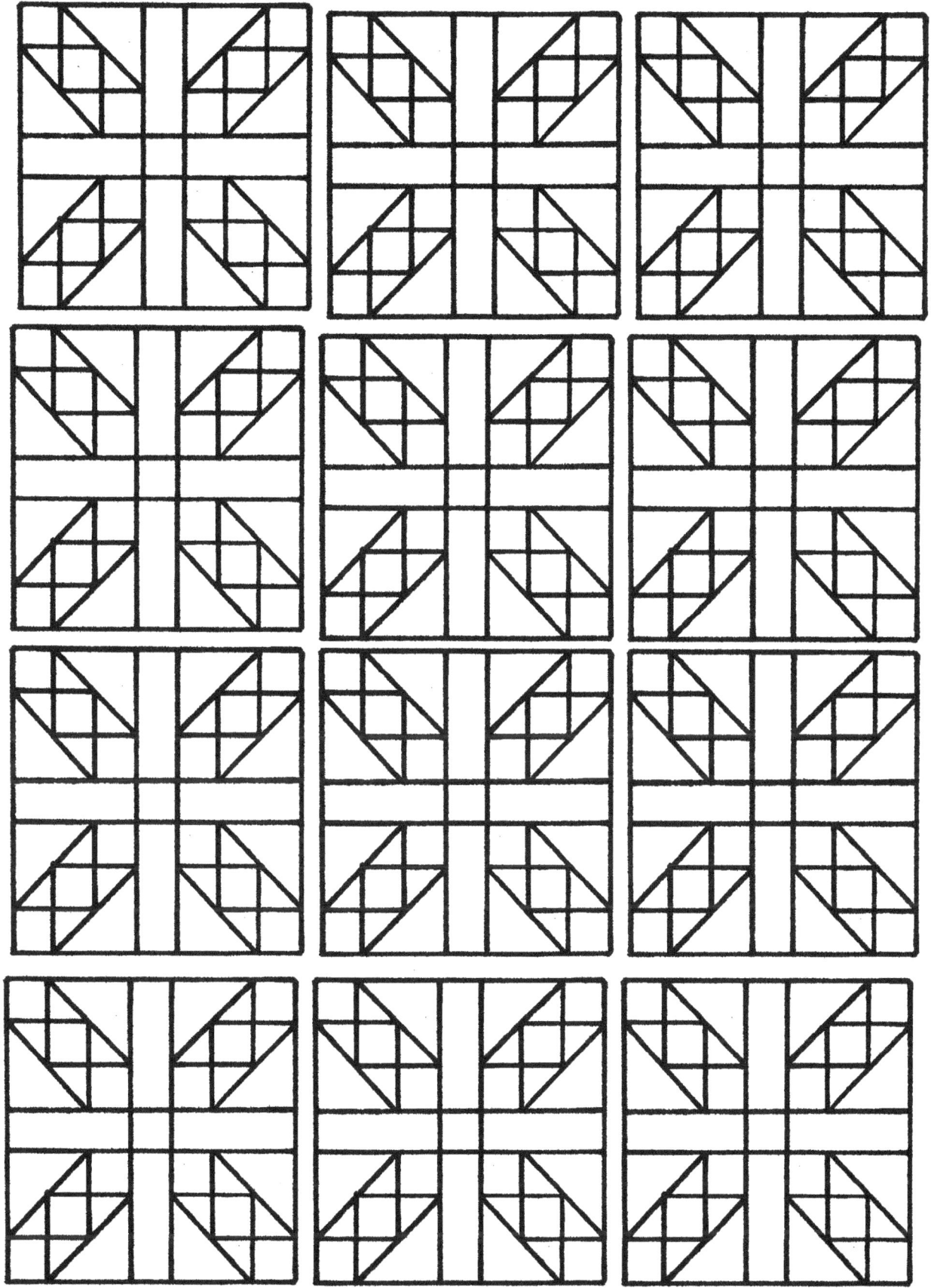

Barn Quilt
Light at the End of the Tunnel
Franklin County Vermont

Barn Quilt Location
Mill St
Sheldon, Vermont

Franklin Barn Quilt
Light at the End of the Tunnel

Barn Quilt Le Moyne Star
Franklin County Vermont

Barn Quilt Location
Main St
Franklin, Vermont

Franklin Barn Quilt Le Moyne Star

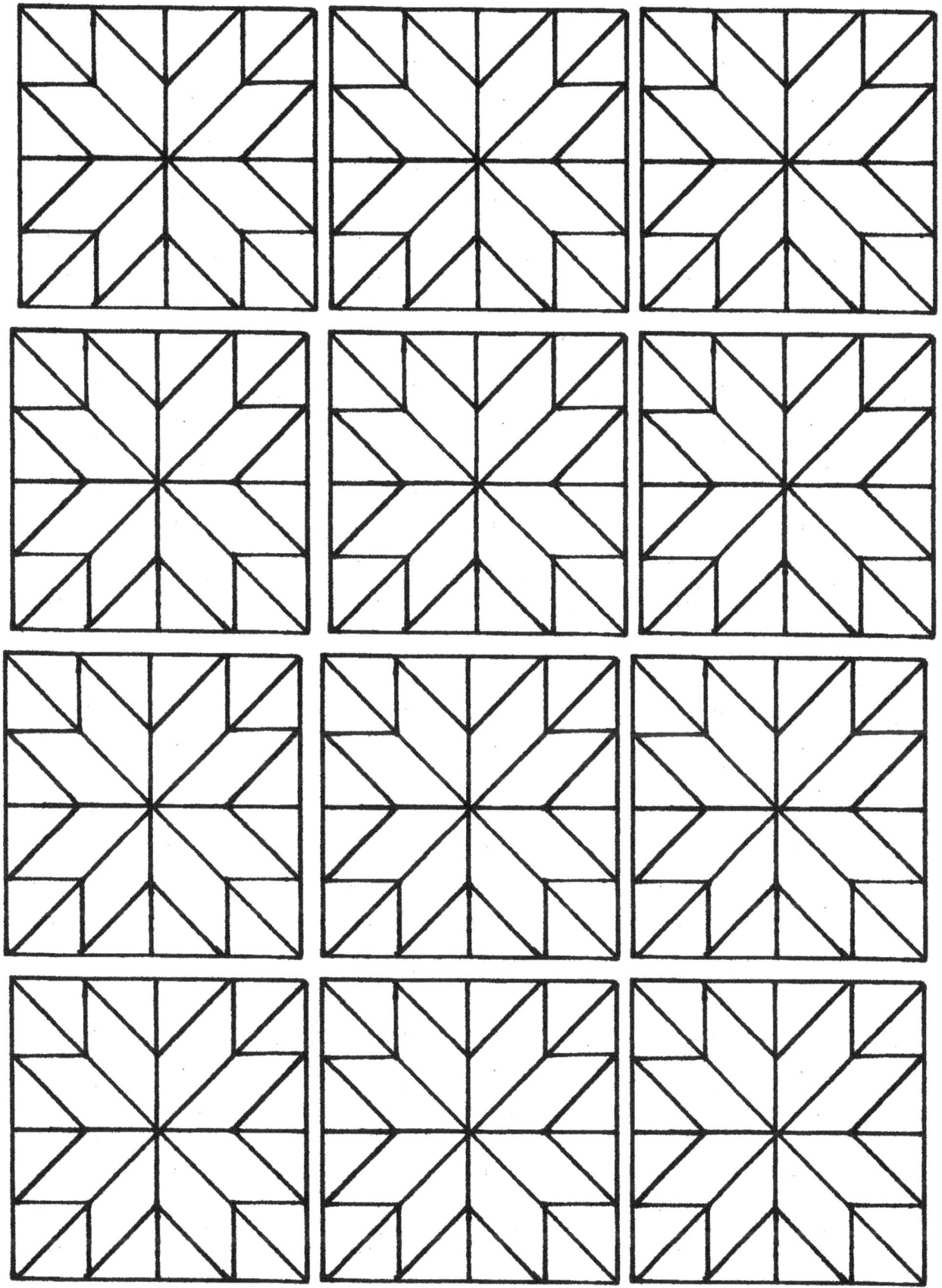

Barn Quilt Turkey Tracks
Franklin County Vermont

Barn Quilt Location
Patton Shore
Franklin, Vermont

Franklin Barn Quilt Turkey Tracks

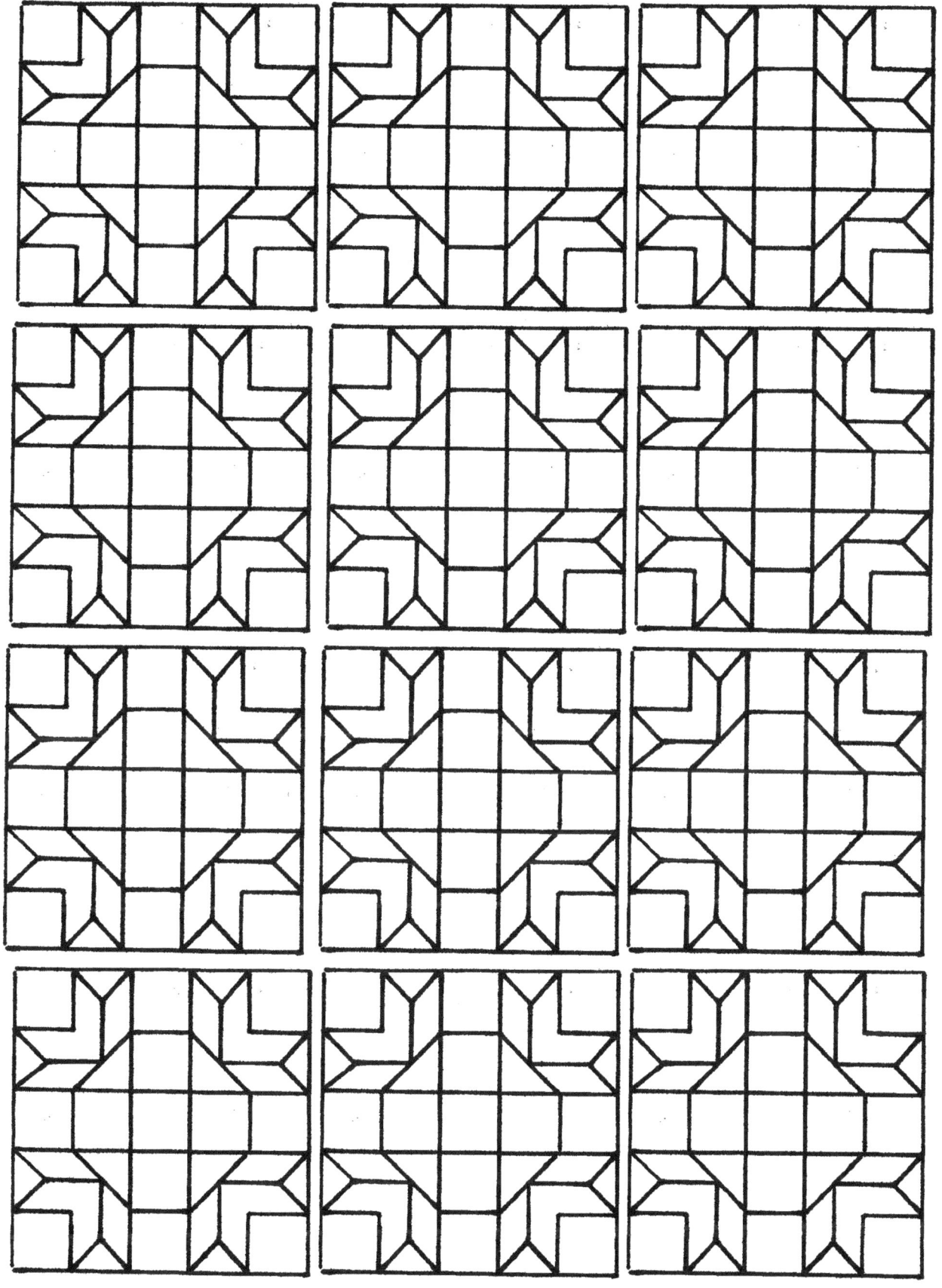

Barn Quilt Wheels
Franklin County Vermont

Barn Quilt Location
Richard Rd
Franklin, Vermont

Franklin Barn Quilt Wheels

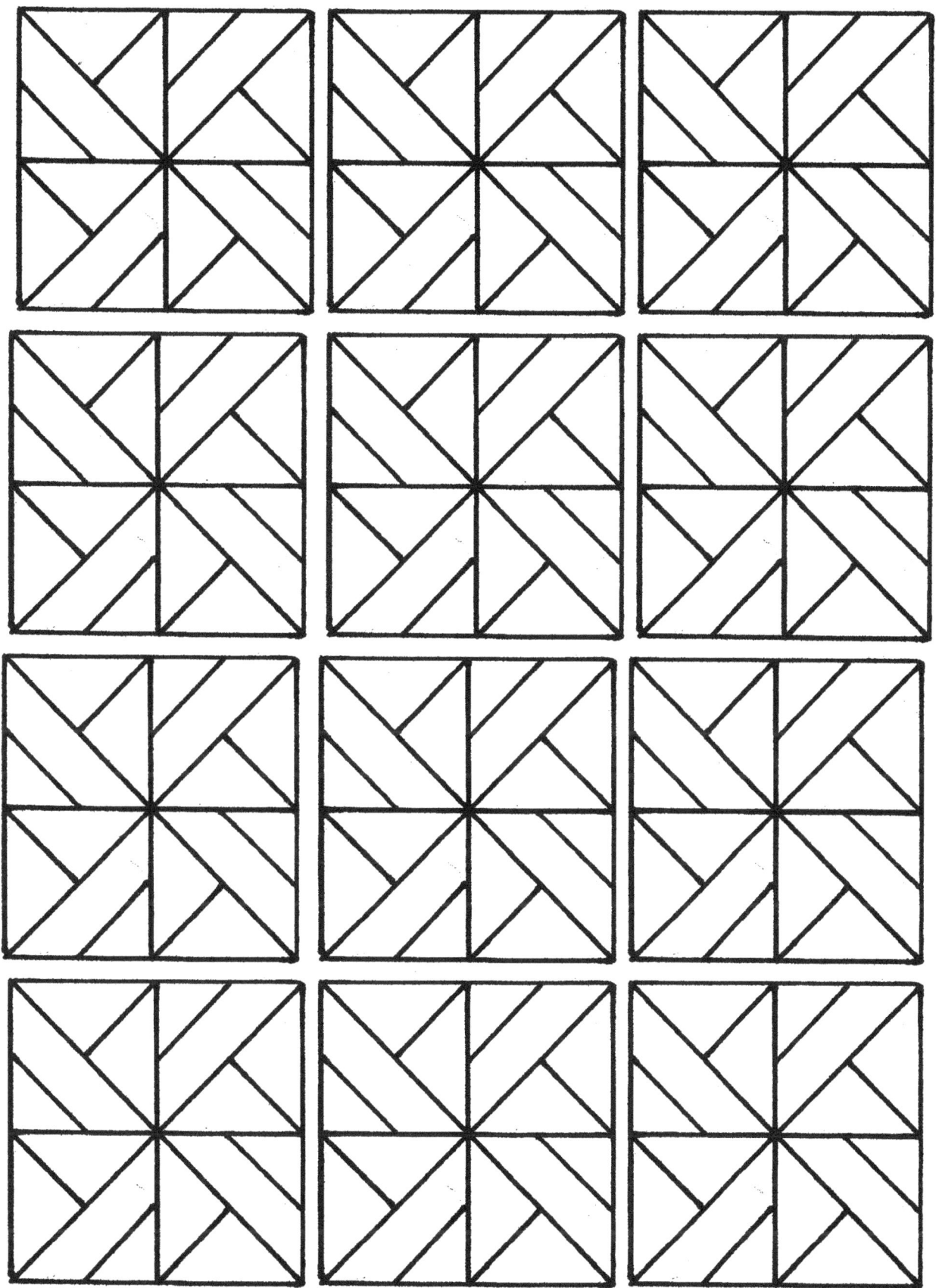

Barn Quilt Double Pinwheel
Franklin County Vermont

Barn Quilt Location
East Sheldon Rd
Sheldon, Vermont

Franklin Barn Double Pinwheel

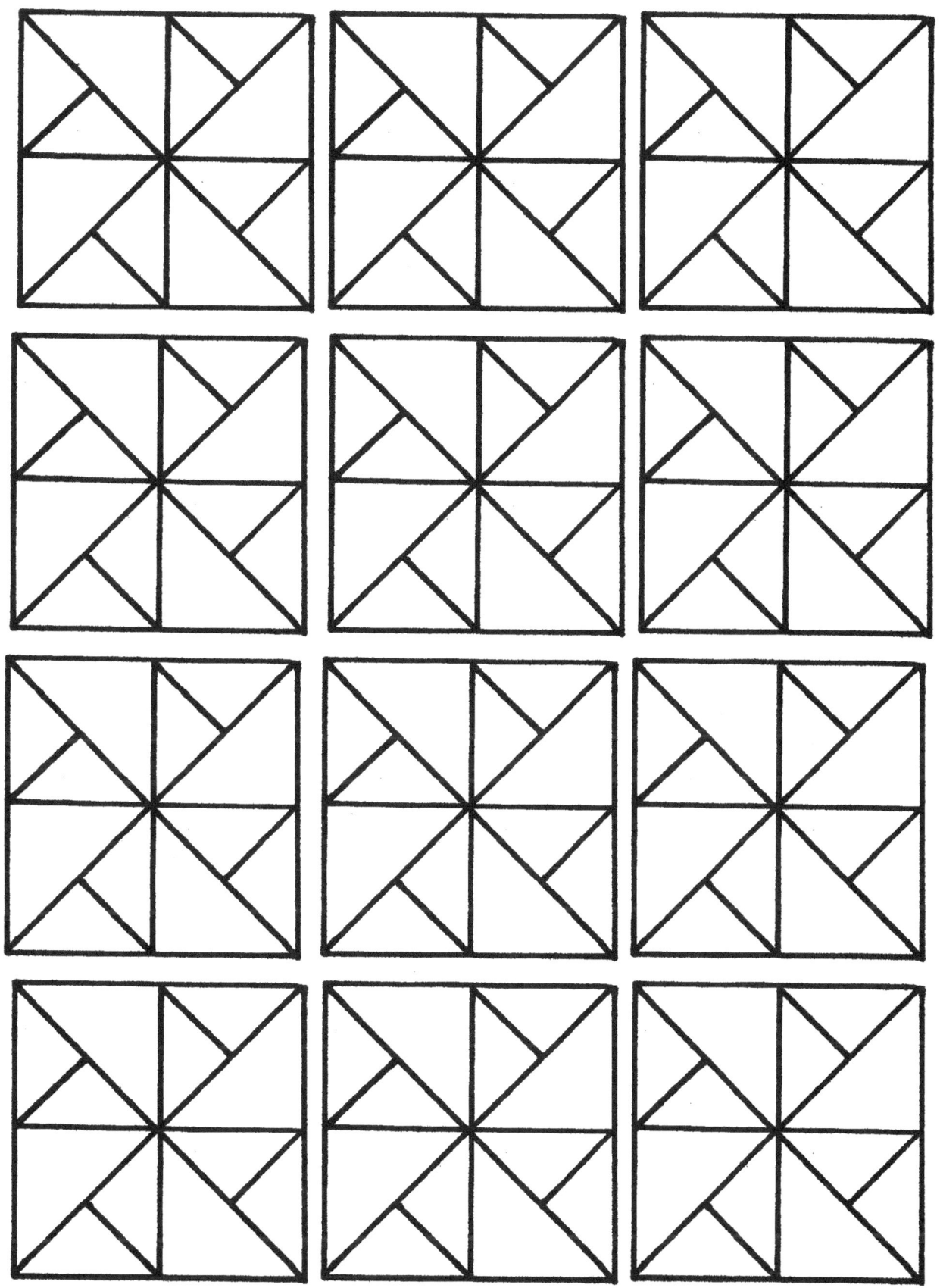

Barn Quilt Best Friend
Franklin County Vermont

Barn Quilt Location
Danyow Rd
Sheldon, Vermont

Franklin Barn Quilt Best Friend

Barn Quilt Hole in the Barn
Franklin County Vermont

Barn Quilt Location
Maple Park
Enosburg, Vermont

Franklin Barn Quilt Hole in the Barn

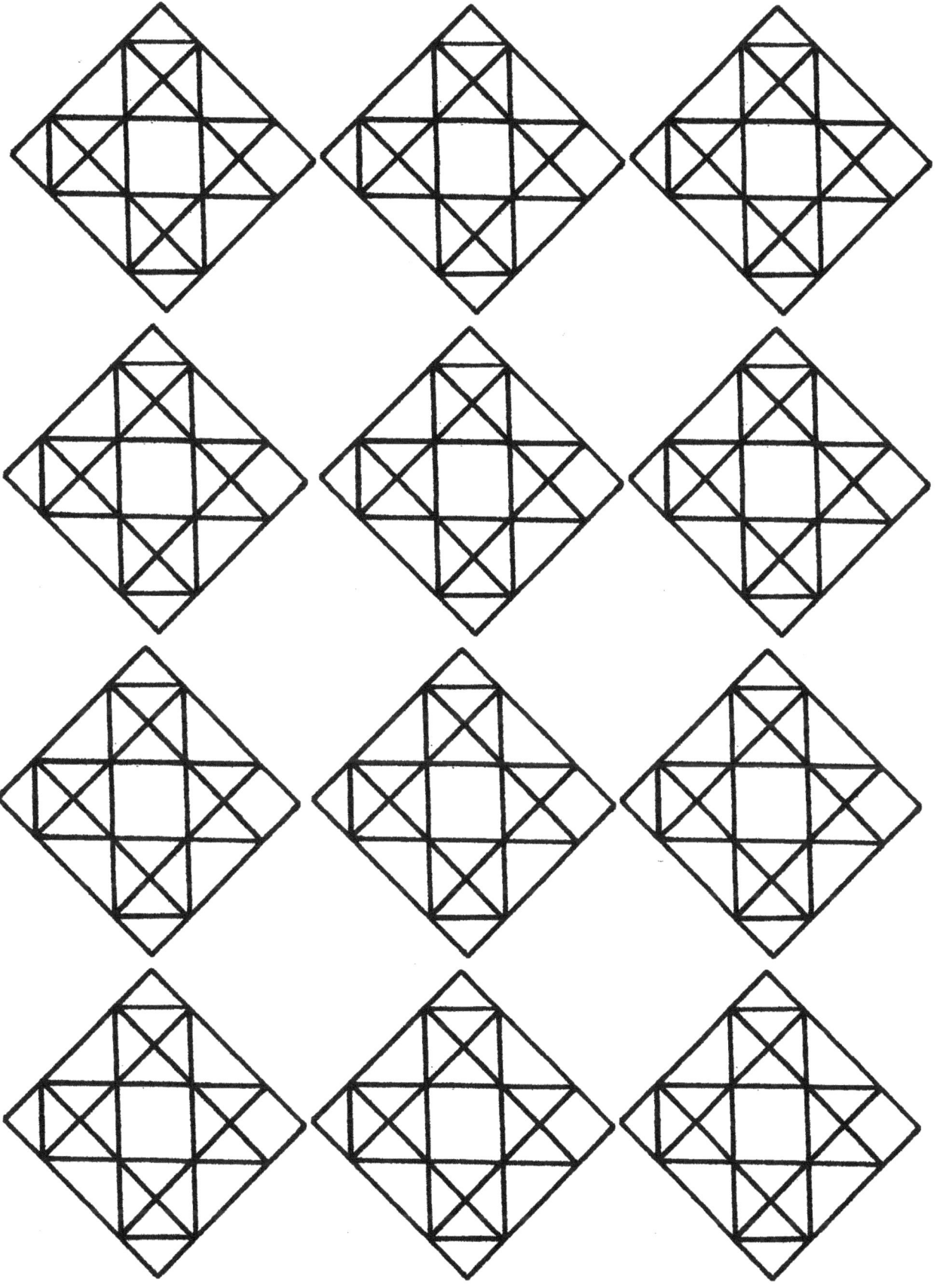

Barn Quilt 4 Point
Franklin County Vermont

Barn Quilt Location
Brown's Corner Rd
Franklin, Vermont

Franklin Barn Quilt 4 Point

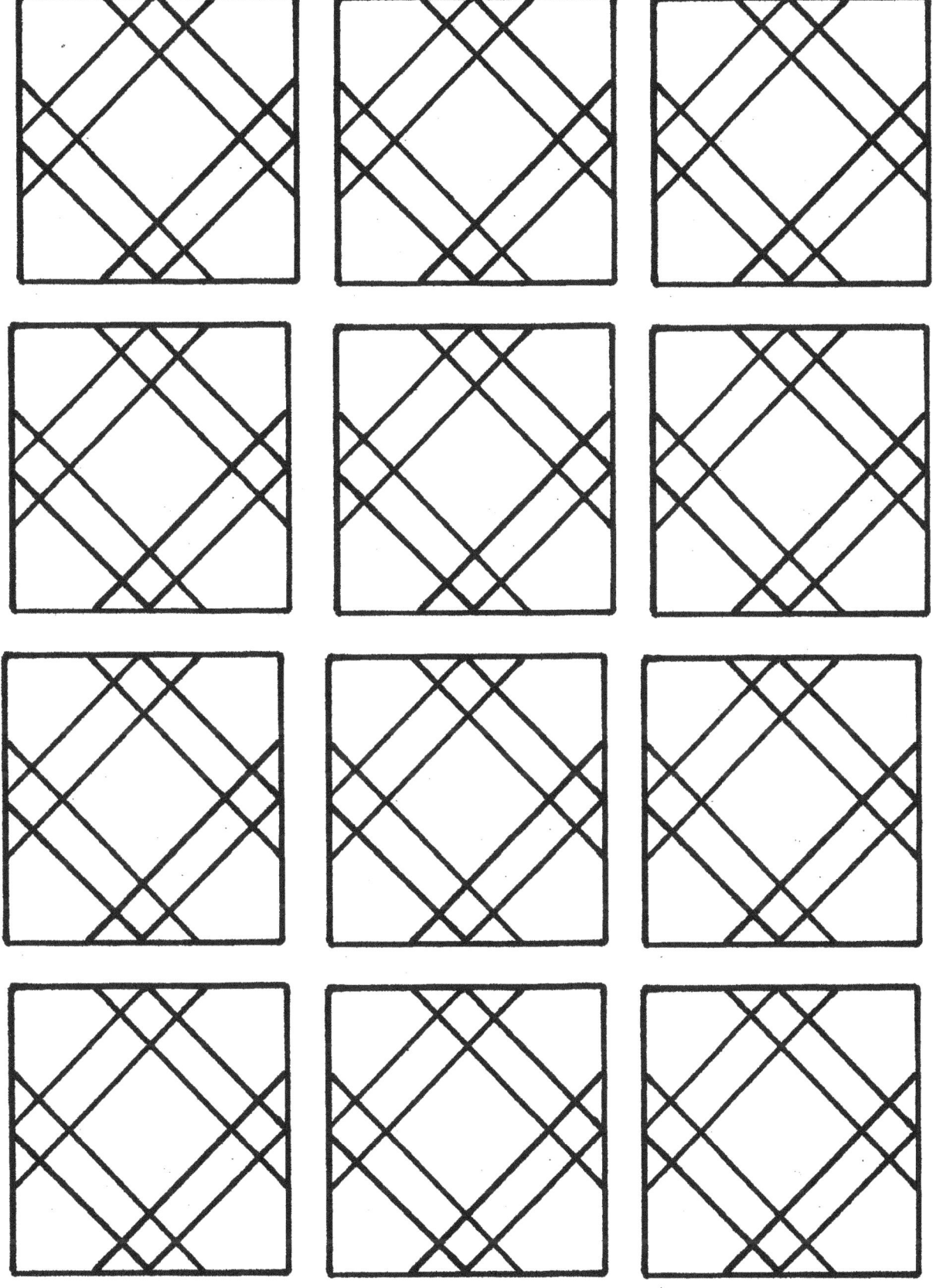

Barn Quilt Ohio Star
Franklin County Vermont

Barn Quilt Location
Berkshire Center Rd
Berkshire, Vermont

Franklin Barn Quilt Ohio Star

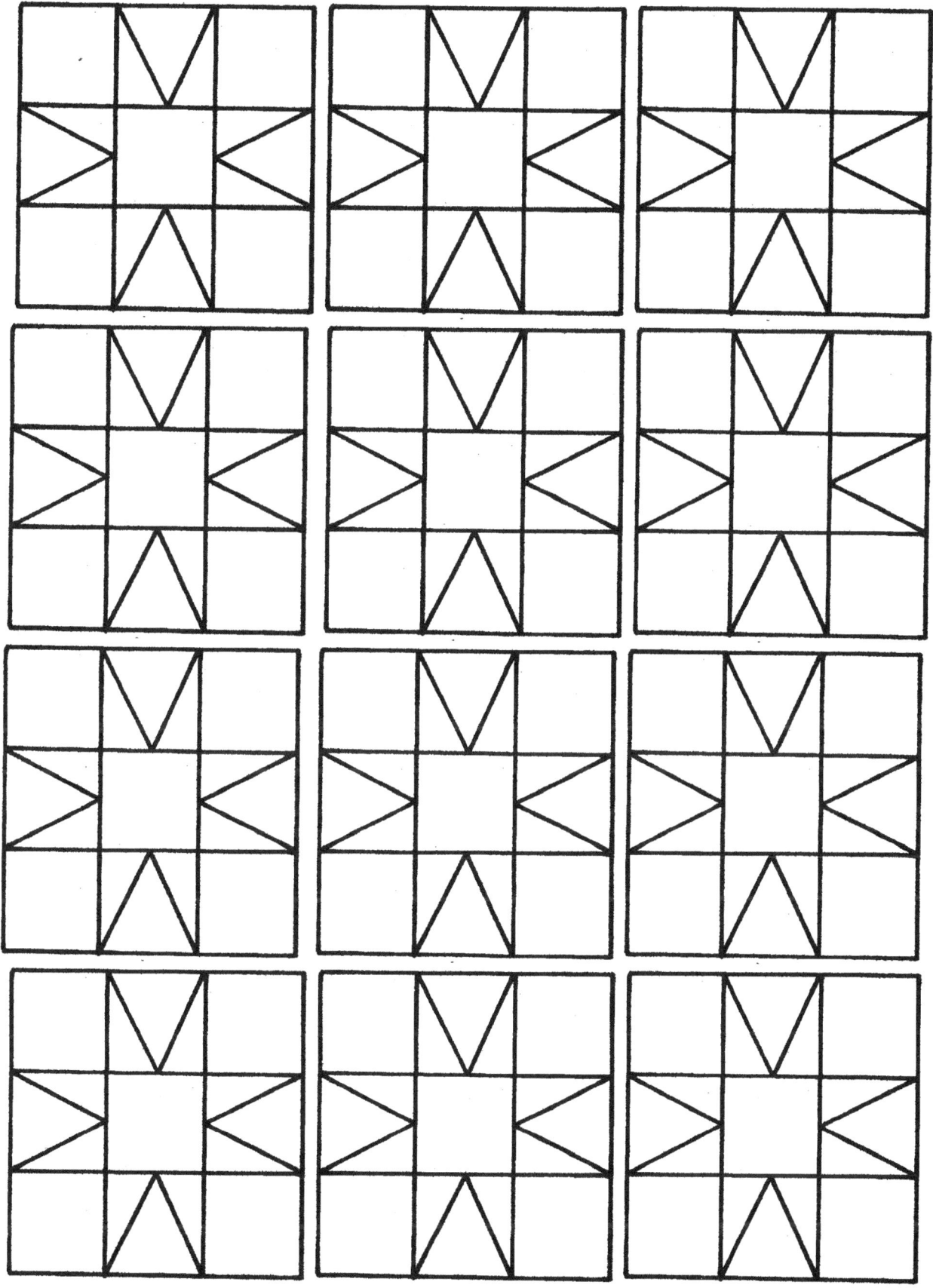

Barn Quilt Carpenter's Wheel
Franklin County Vermont

Barn Quilt Location
Davis Rd
Enosburg, Vermont

Franklin Barn Quilt Carpenter's Wheel

Barn Quilt Wheel of Fortune
Franklin County Vermont

Barn Quilt Location
Tyler Branch Rd
Enosburg, Vermont

Franklin Barn Quilt Wheel of Fortune

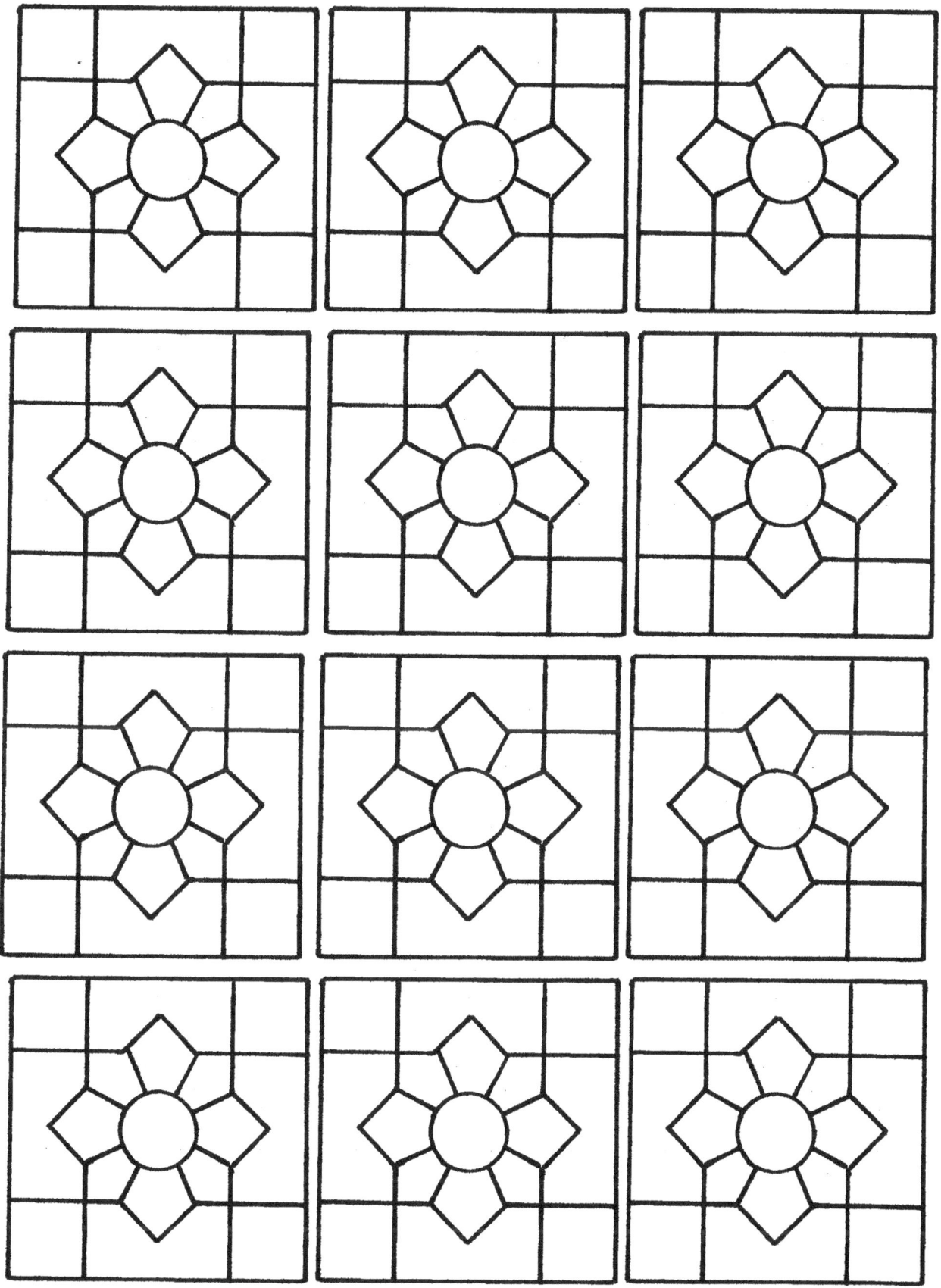

Barn Quilt Snowball
Franklin County Vermont

Barn Quilt Location
Boston Post Rd
Enosburg, Vermont

Franklin Barn Quilt Snowball

Barn Quilt Maple Leaf
Franklin County Vermont

Barn Quilt Location
West Enosburg Rd
Enosburg, Vermont

Franklin Barn Quilt Maple Leaf

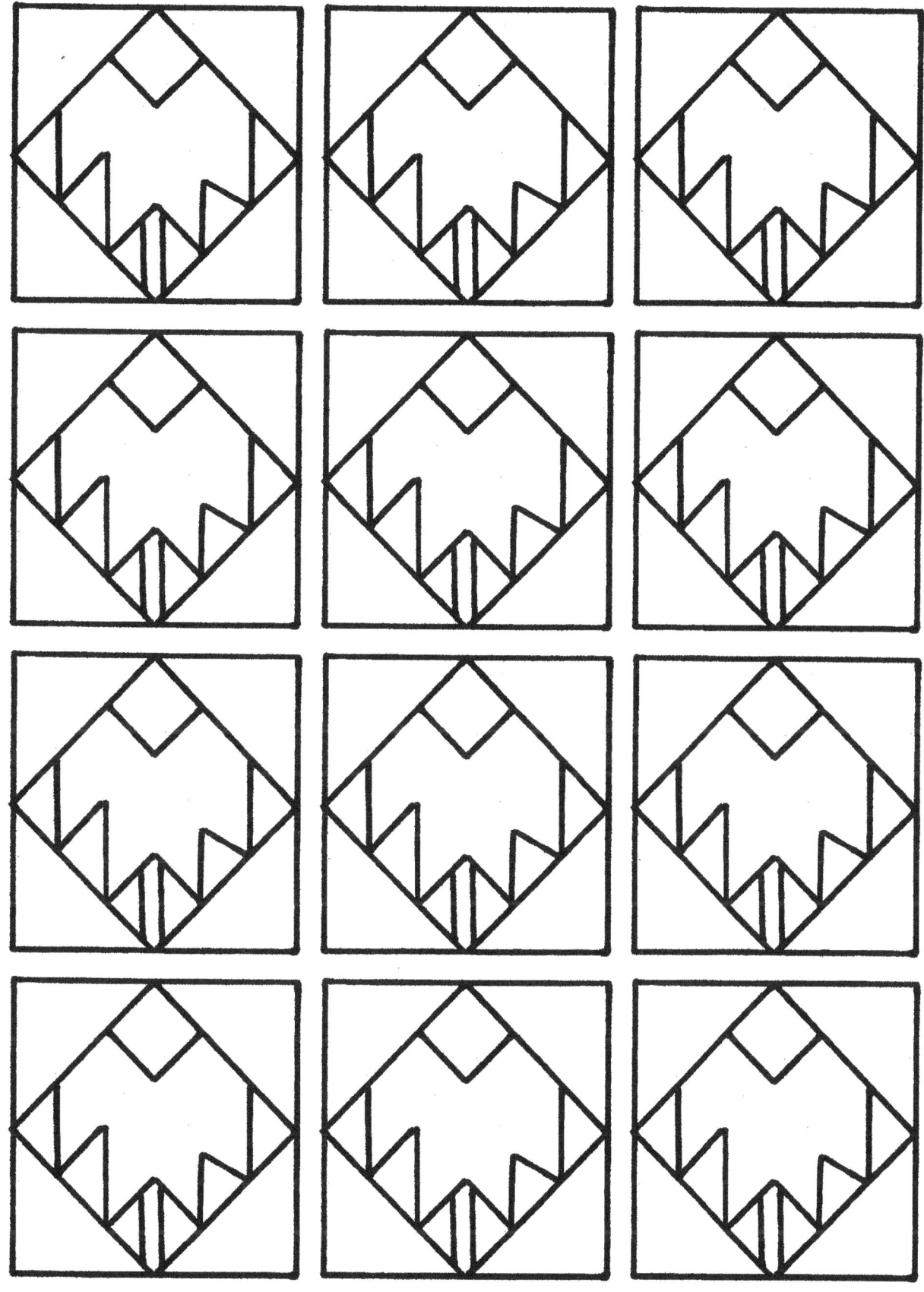

Barn Quilt Bear Paw
Franklin County Vermont

Barn Quilt Location
27 Park St
Fairfield, Vermont

Franklin Barn Quilt Bear Paw

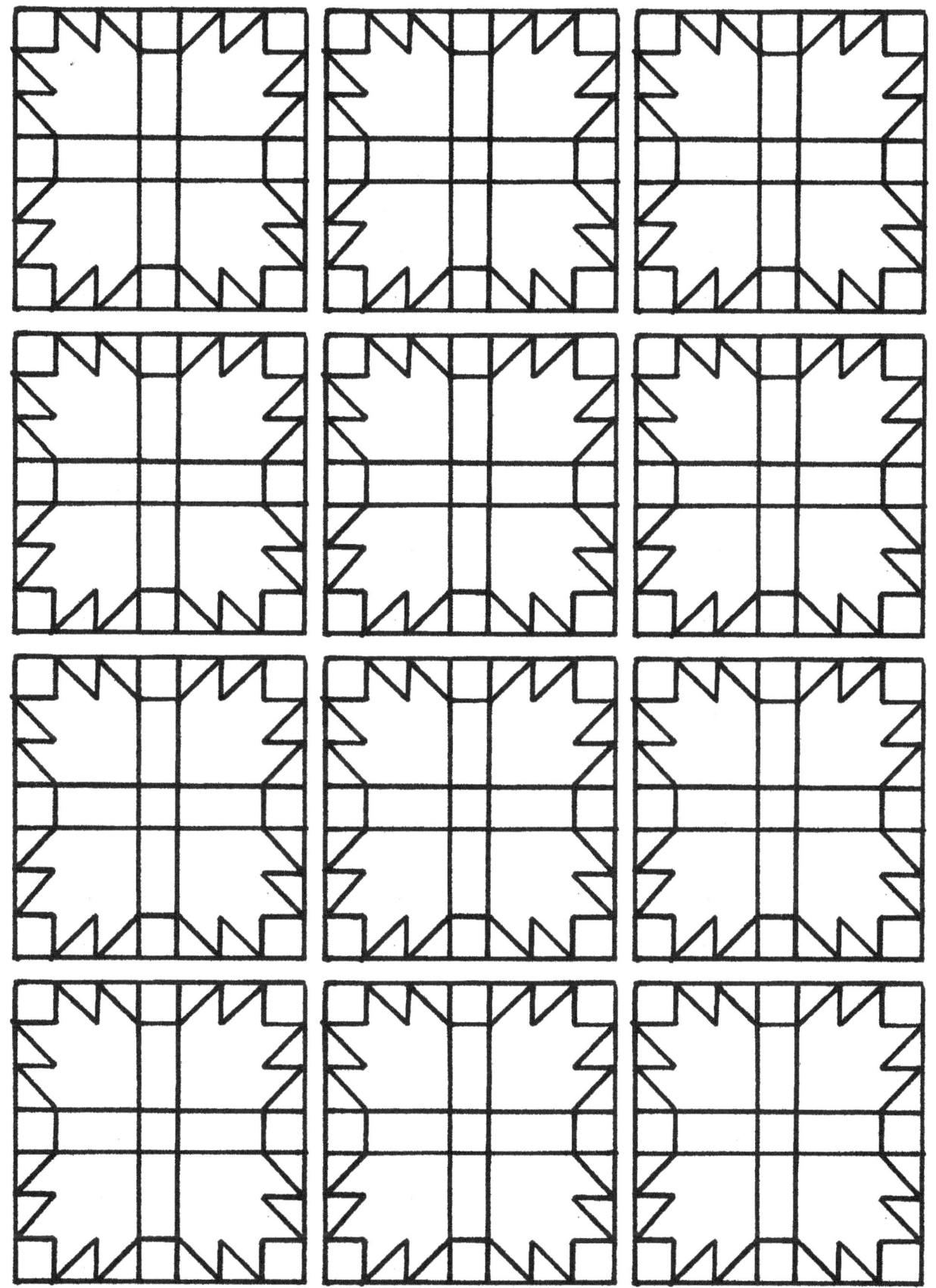

Barn Quilt Buggy Wheel
Franklin County Vermont

Barn Quilt Location
North Main St
Montgomery, Vermont

Franklin Barn Quilt Buggy Wheel

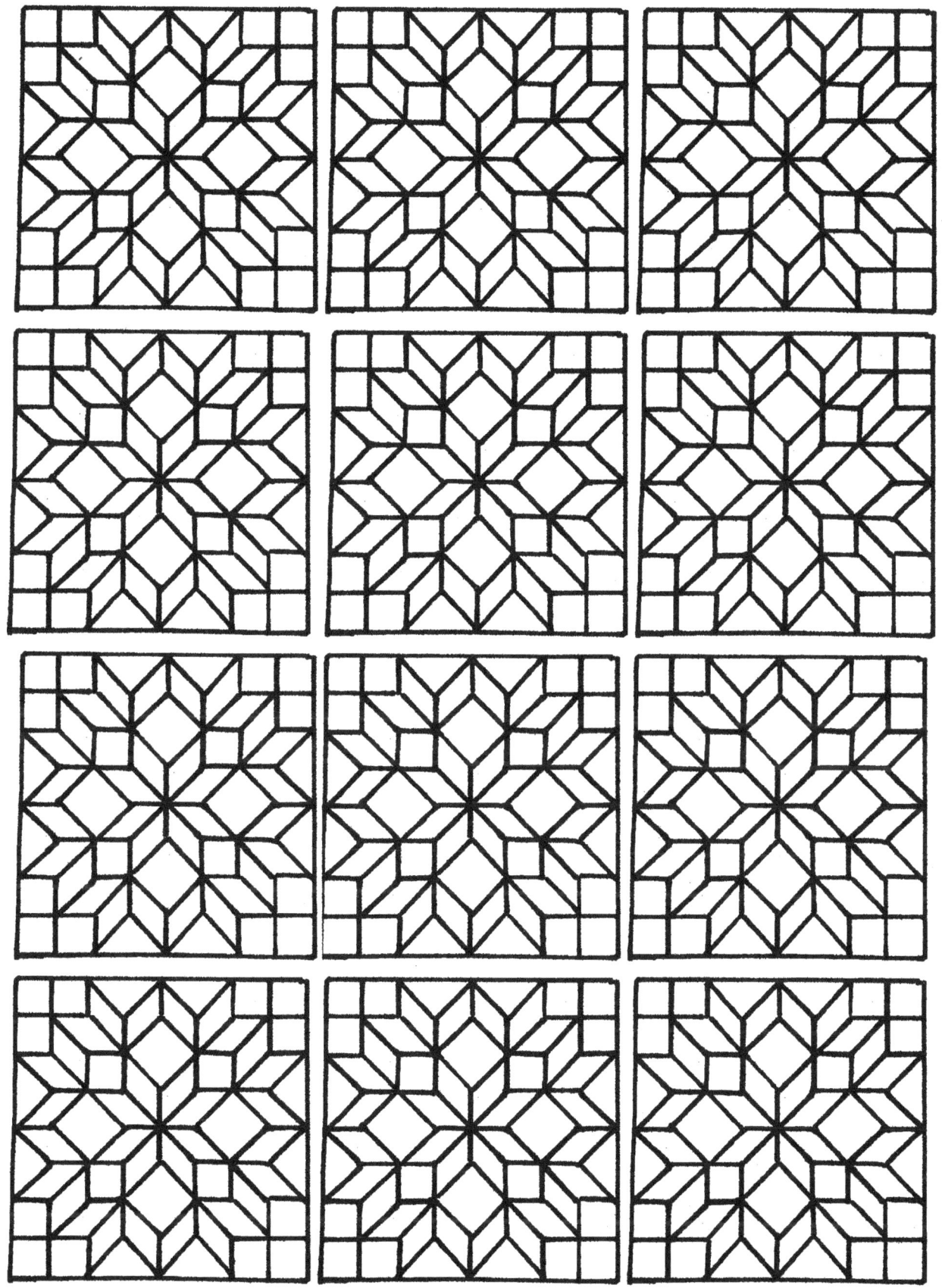

Barn Quilt Chained Star
Franklin County Vermont

Barn Quilt Location
Richford Rd
Richford, Vermont

Franklin Barn Quilt Chained Star

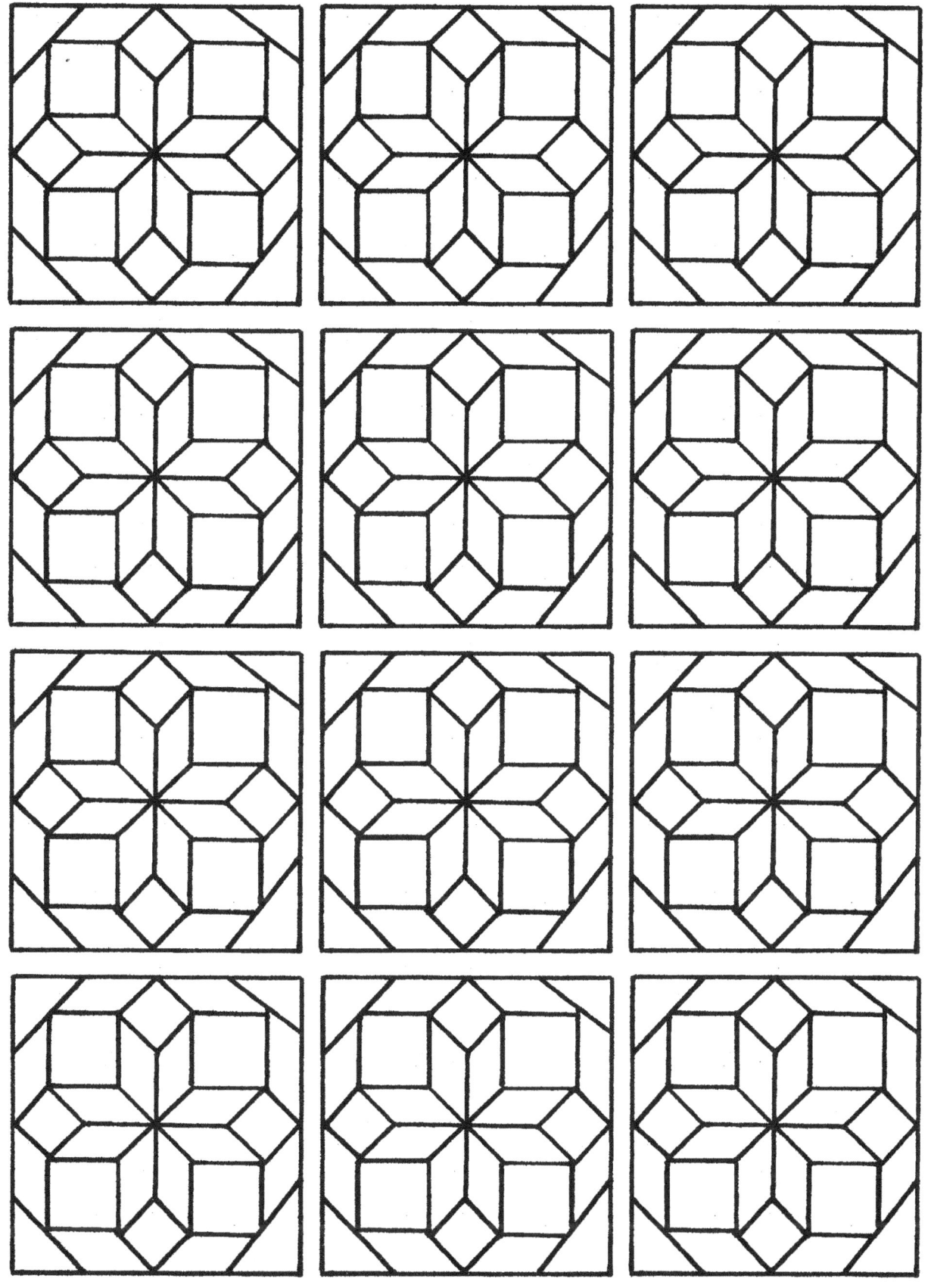

Barn Quilt Broken Wheel
Franklin County Vermont

Barn Quilt Location
West Berkshire Rd
Berkshire, Vermont

Franklin Barn Quilt Broken Wheel

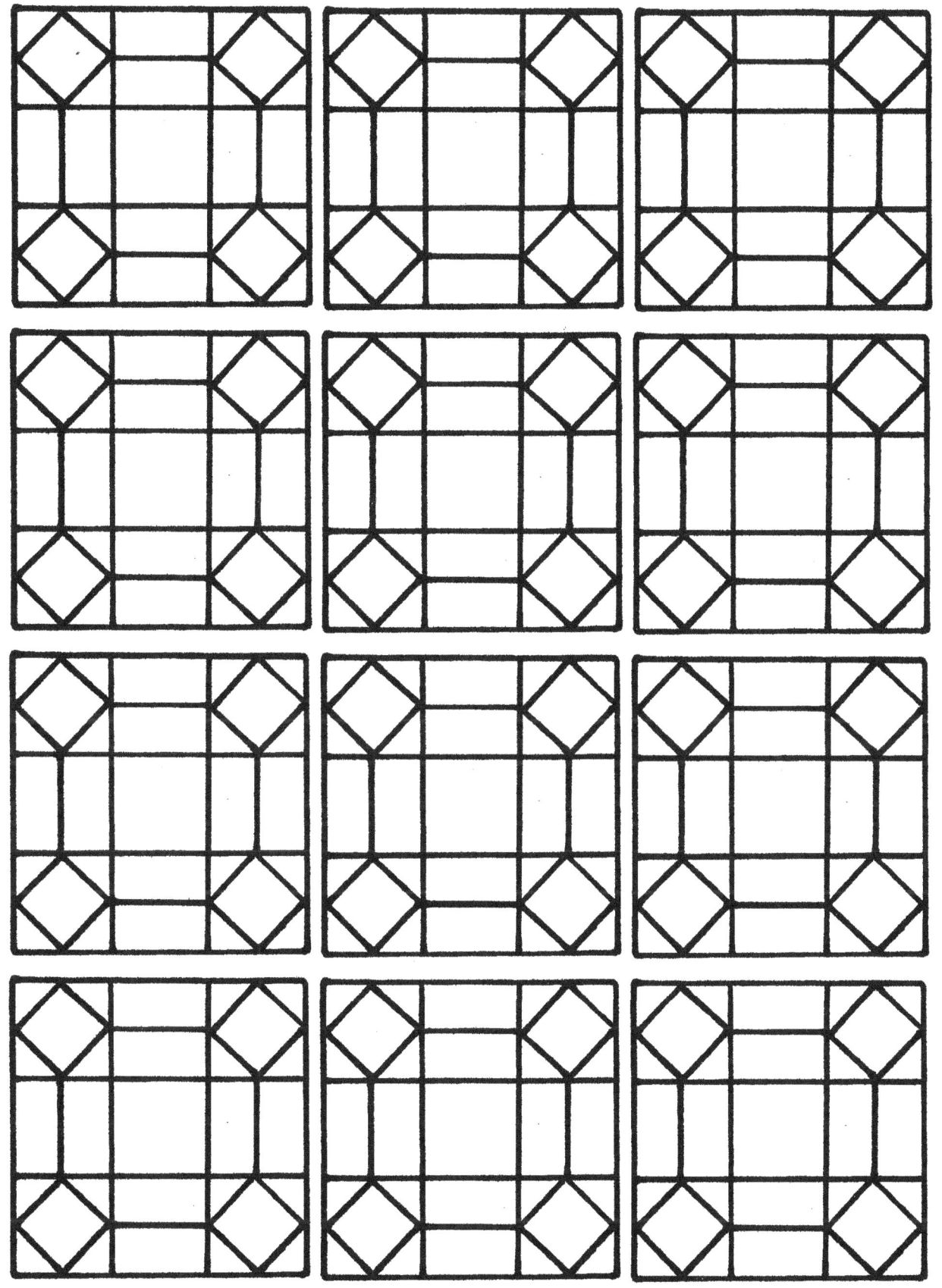

Barn Quilt Windblown Lily
Franklin County Vermont

Barn Quilt Location
King Rd
Berkshire, Vermont

Franklin Barn Quilt Windblown Lily

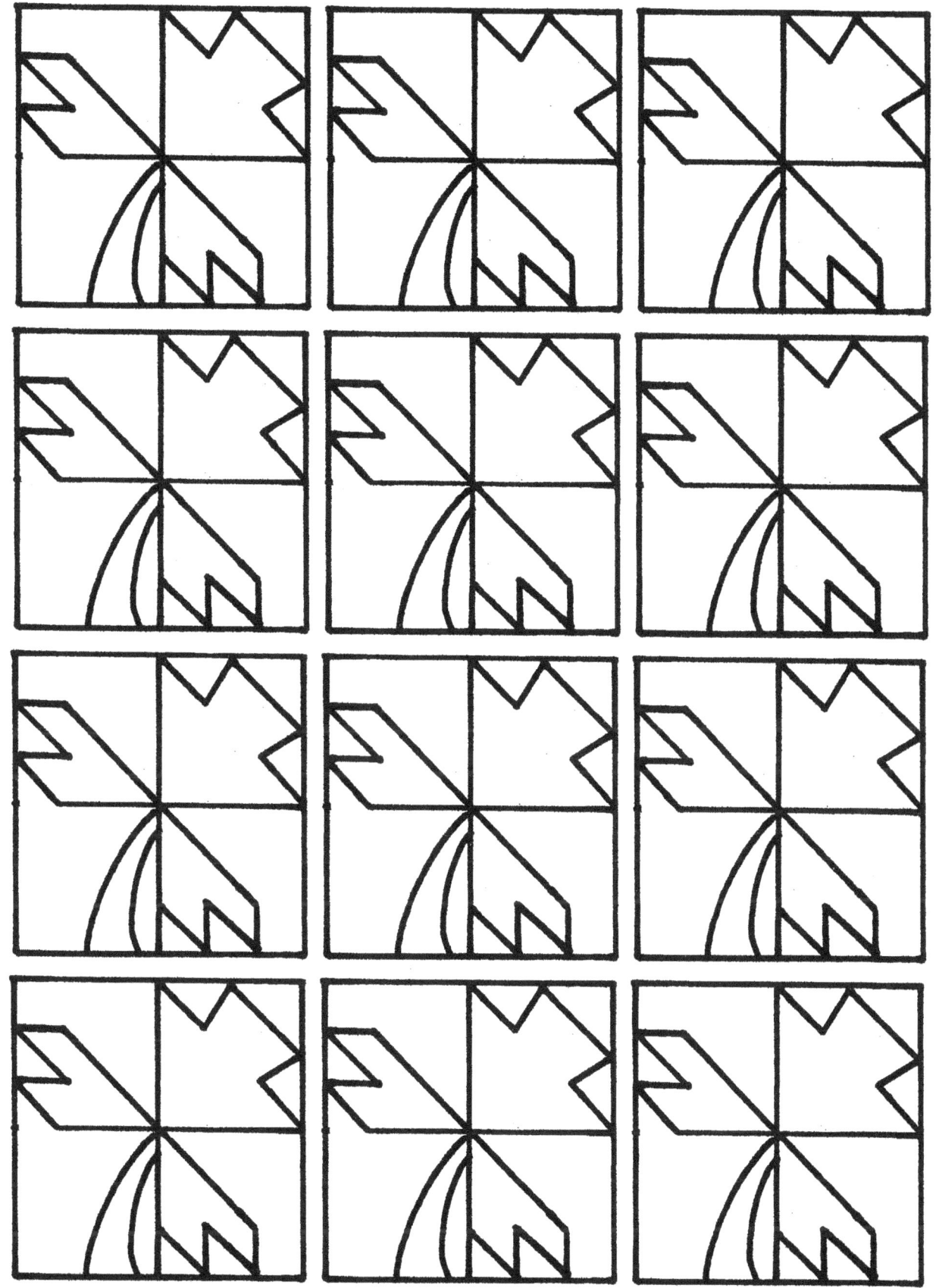

Barn Quilt Commencement
Franklin County Vermont

Barn Quilt Location
Corliss Rd
Richford, Vermont

Franklin Barn Quilt Commencement

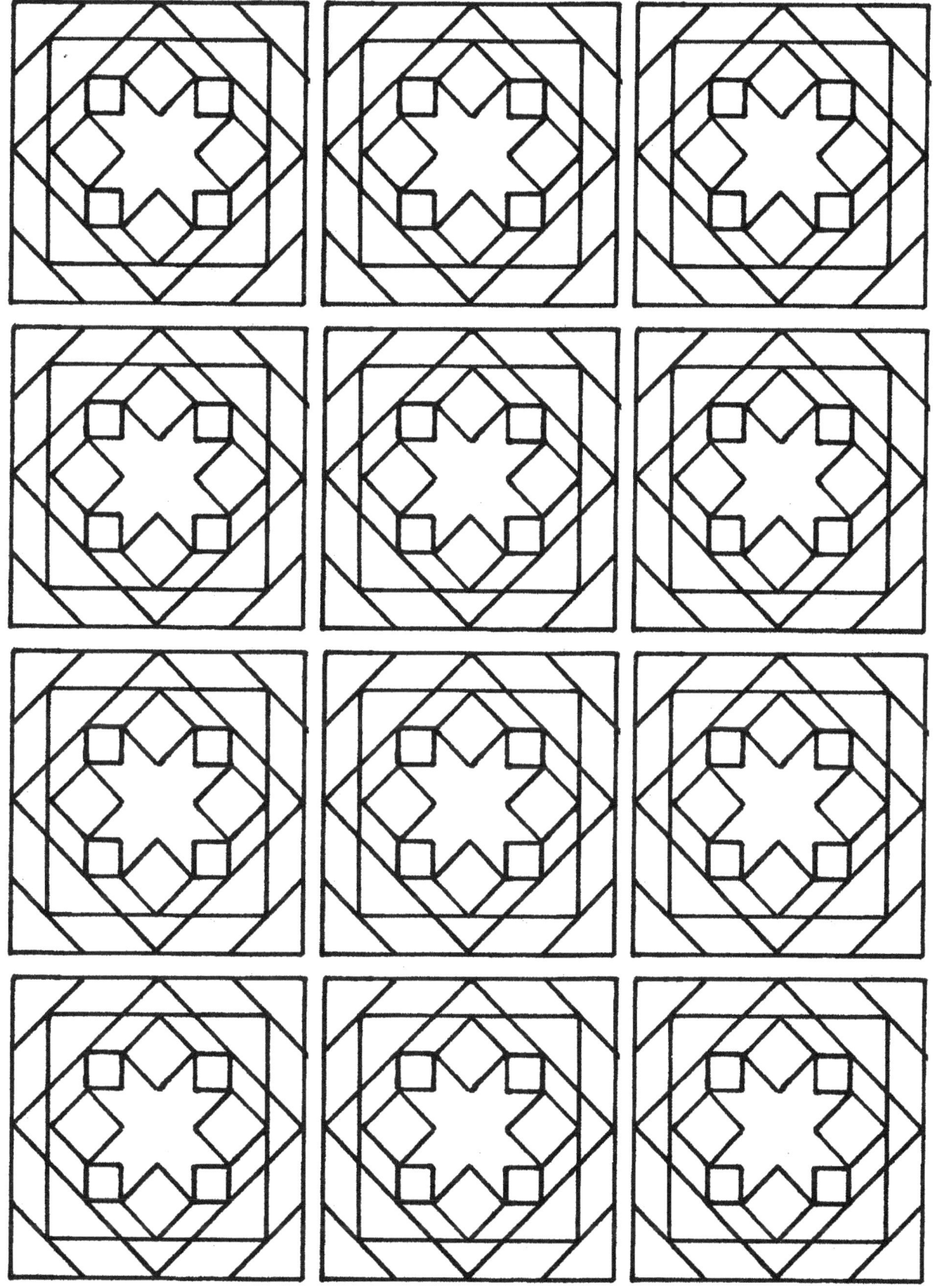

Barn Quilt Peony
Franklin County Vermont

Barn Quilt Location
AA Brown Lib Main St
Richford, Vermont

Franklin Barn Quilt Peony

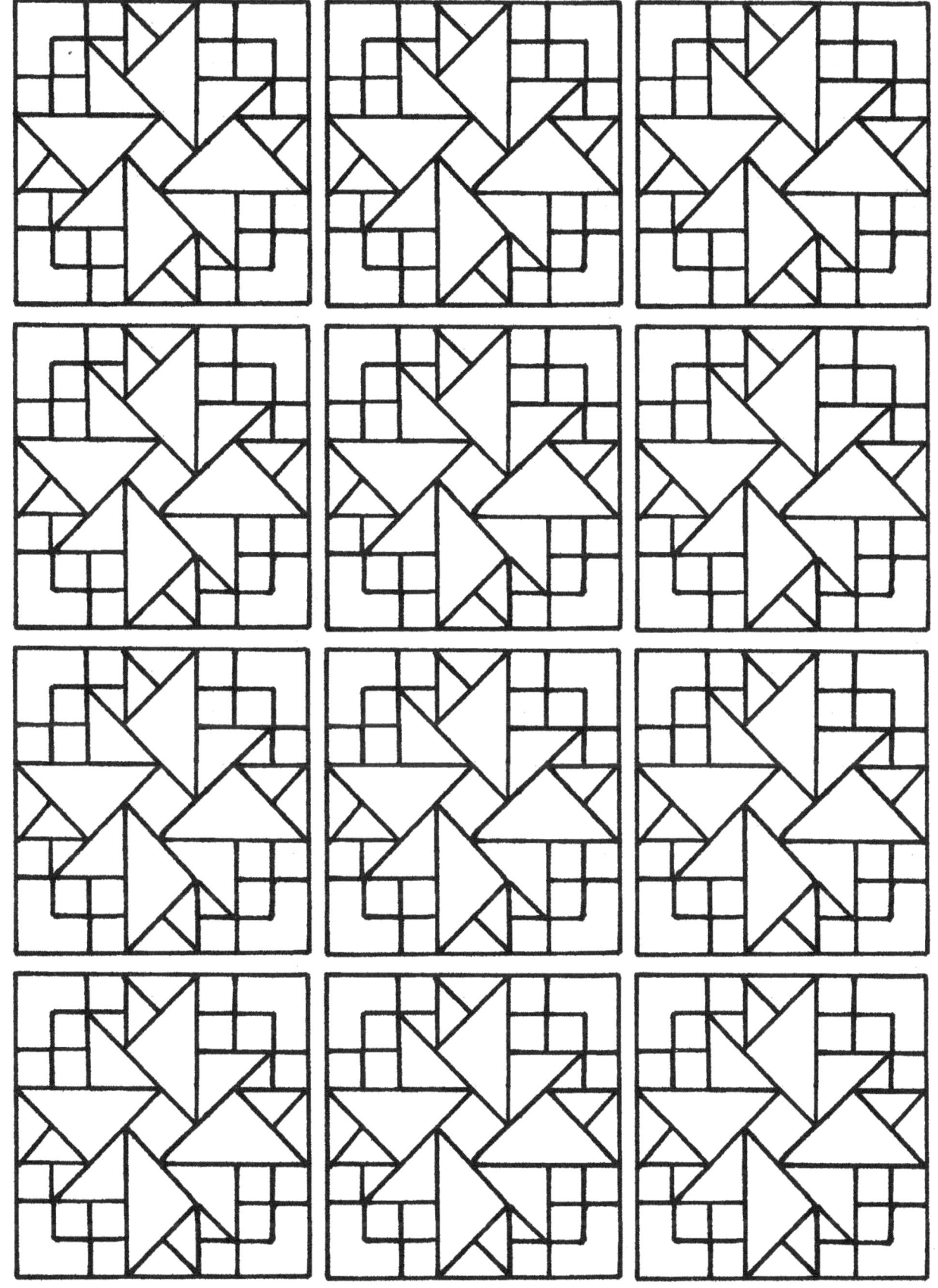

Barn Quilt Friendship
Franklin County Vermont

Barn Quilt Location
Rte 105
Sheldon, Vermont

Franklin Barn Quilt Friendship

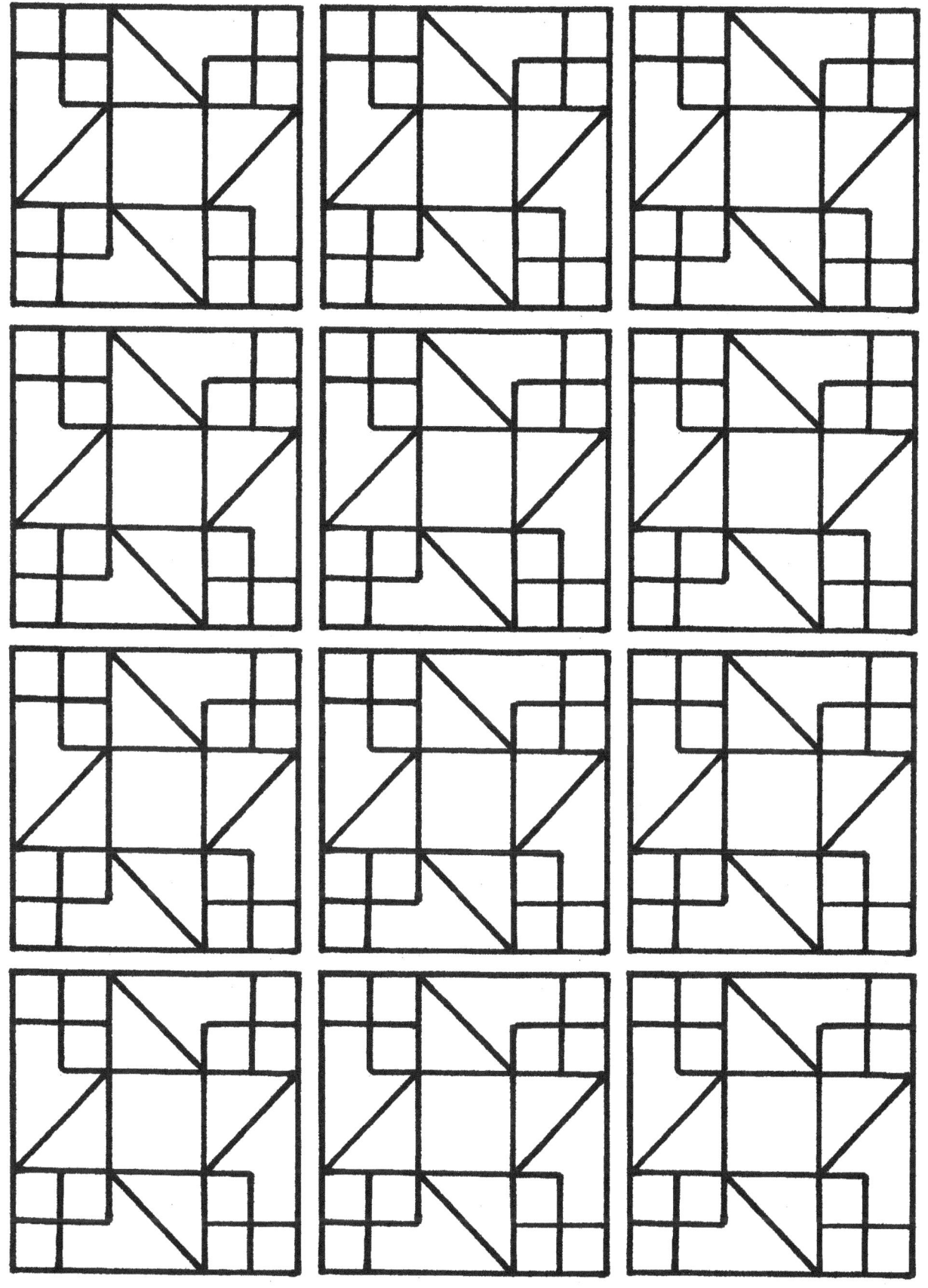

Barn Quilt Fly a Kite
Franklin County Vermont

Barn Quilt Location
Sheldon Heights
Sheldon, Vermont

Franklin Barn Quilt Fly a Kite

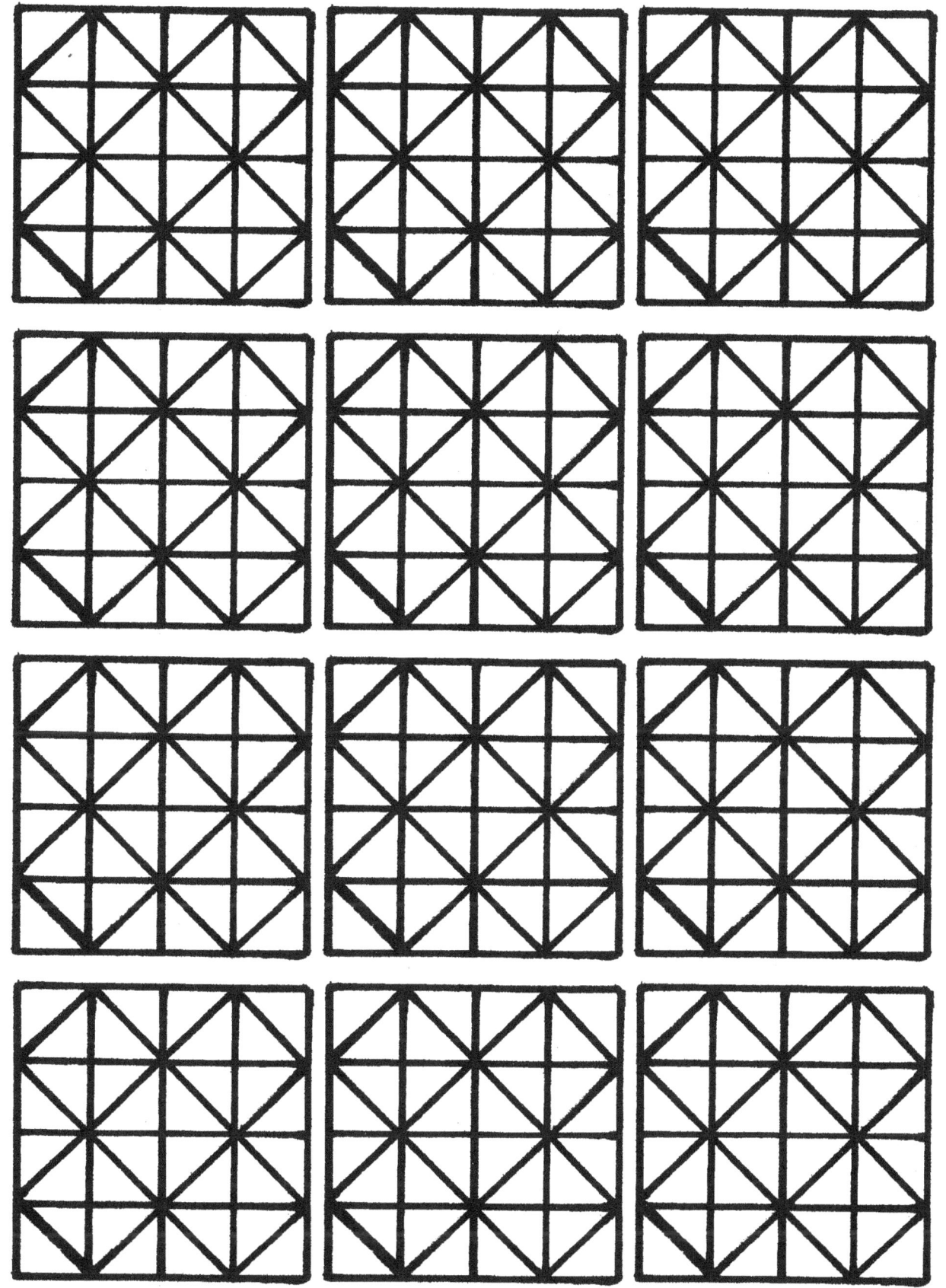

Barn Quilt Galaxy
Franklin County Vermont

Barn Quilt Location
Sheldon Rd
Sheldon, Vermont

Franklin Barn Quilt Galaxy

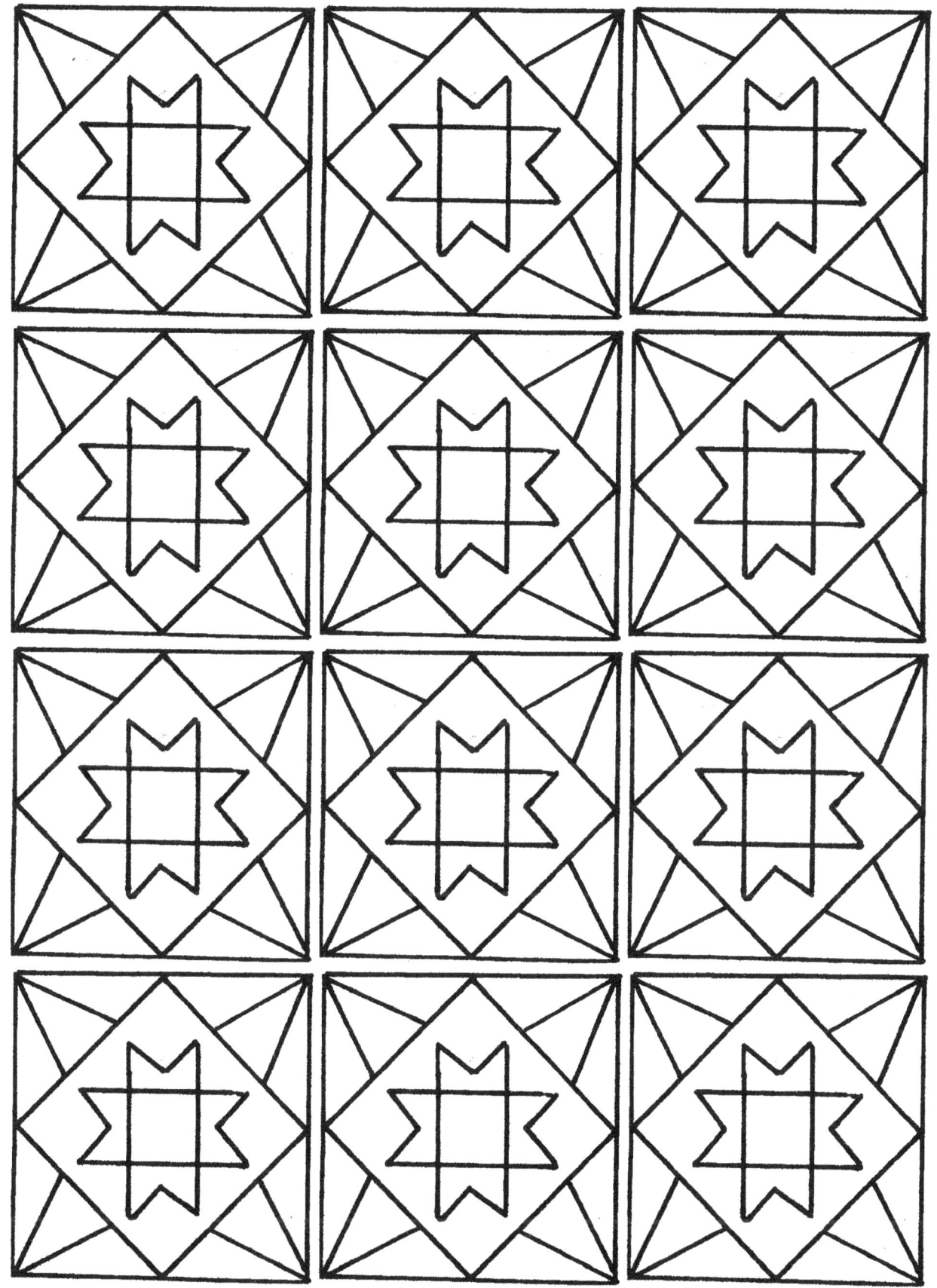

Barn Quilt Seasonal
Franklin County Vermont

Barn Quilt Location
Rte 105
Sheldon, Vermont

Franklin Barn Quilt Seasonal

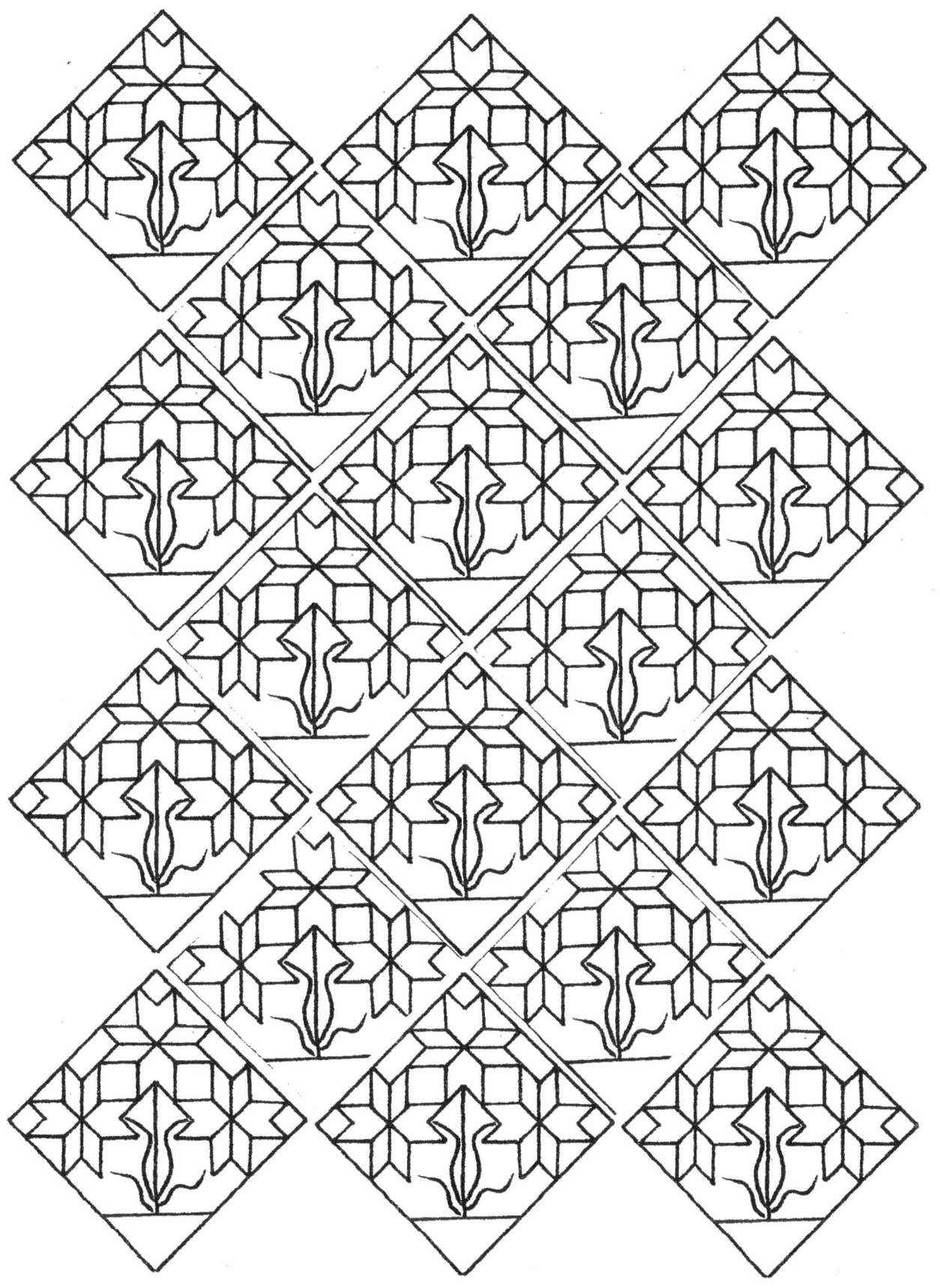

Barn Quilt Shooting Star
Franklin County Vermont

Barn Quilt Location
Mill St
Sheldon, Vermont

Franklin Barn Quilt Shooting Star

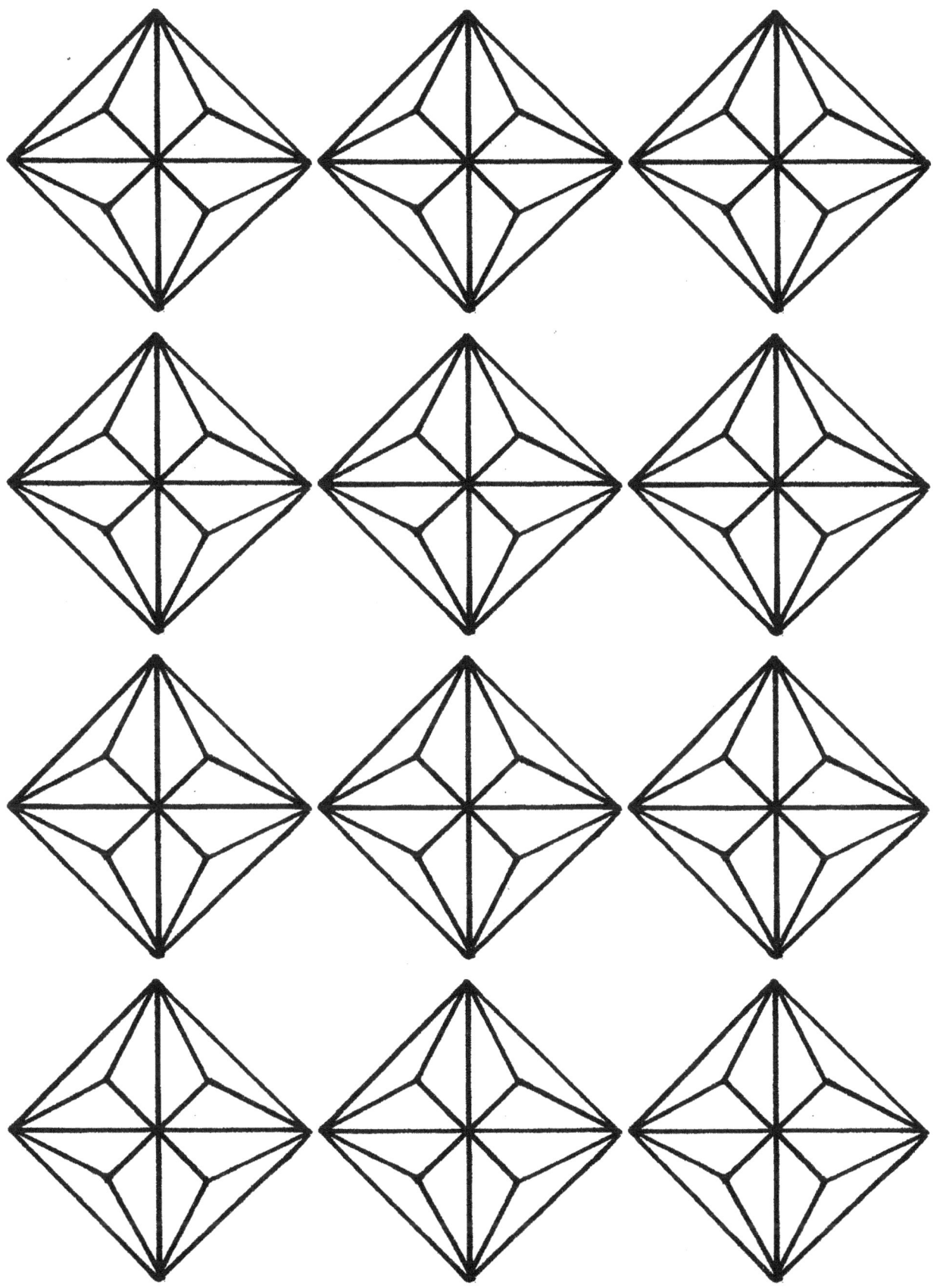

Barn Quilt Tulips
Franklin County Vermont

Barn Quilt Location
Guilmette Rd
Richford, Vermont

Franklin Barn Quilt Tulips

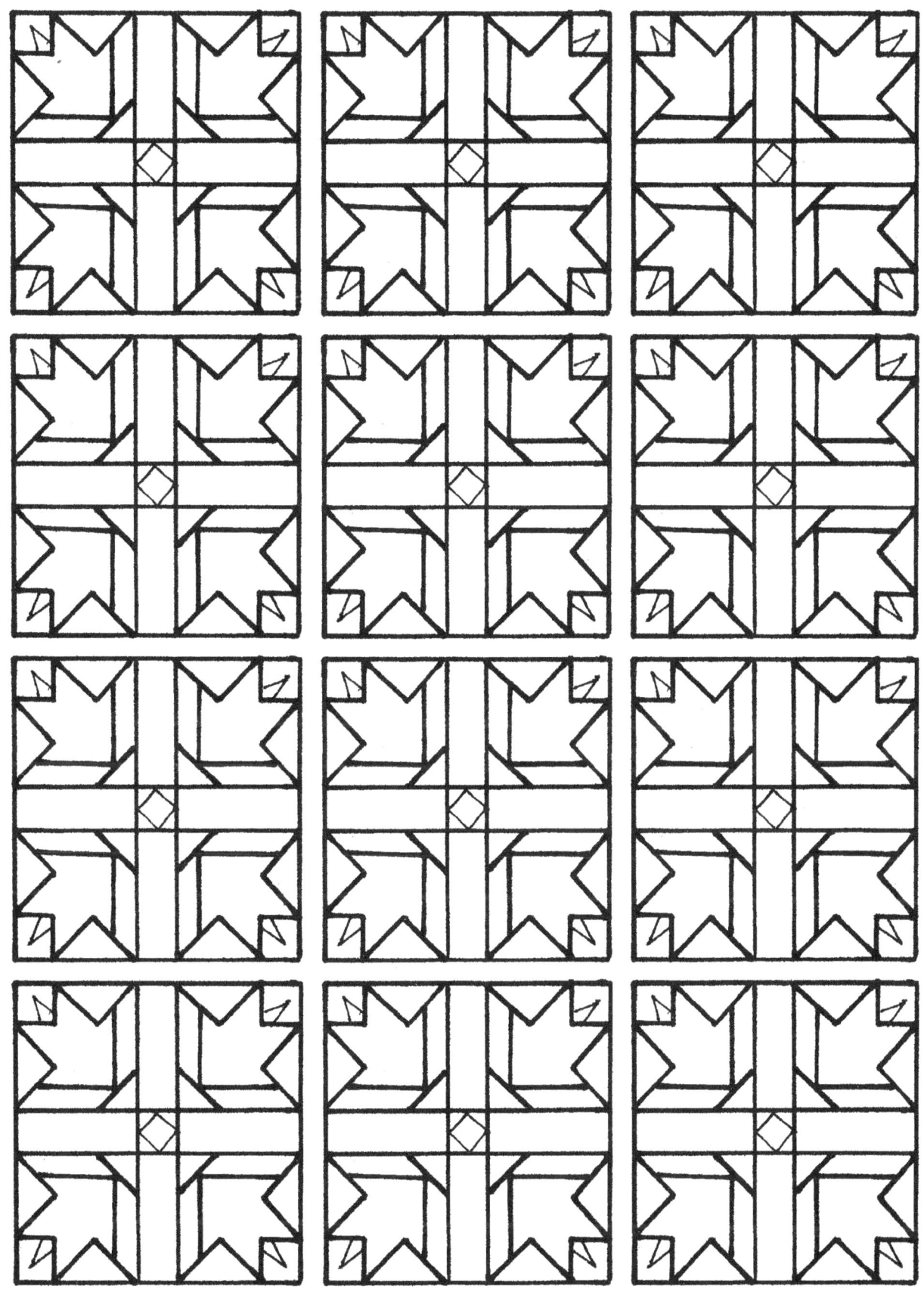

Barn Quilt Beagle
Franklin County Vermont

Barn Quilt Location
Guilmette Rd
Richford, Vermont

Franklin Barn Quilt Beagle

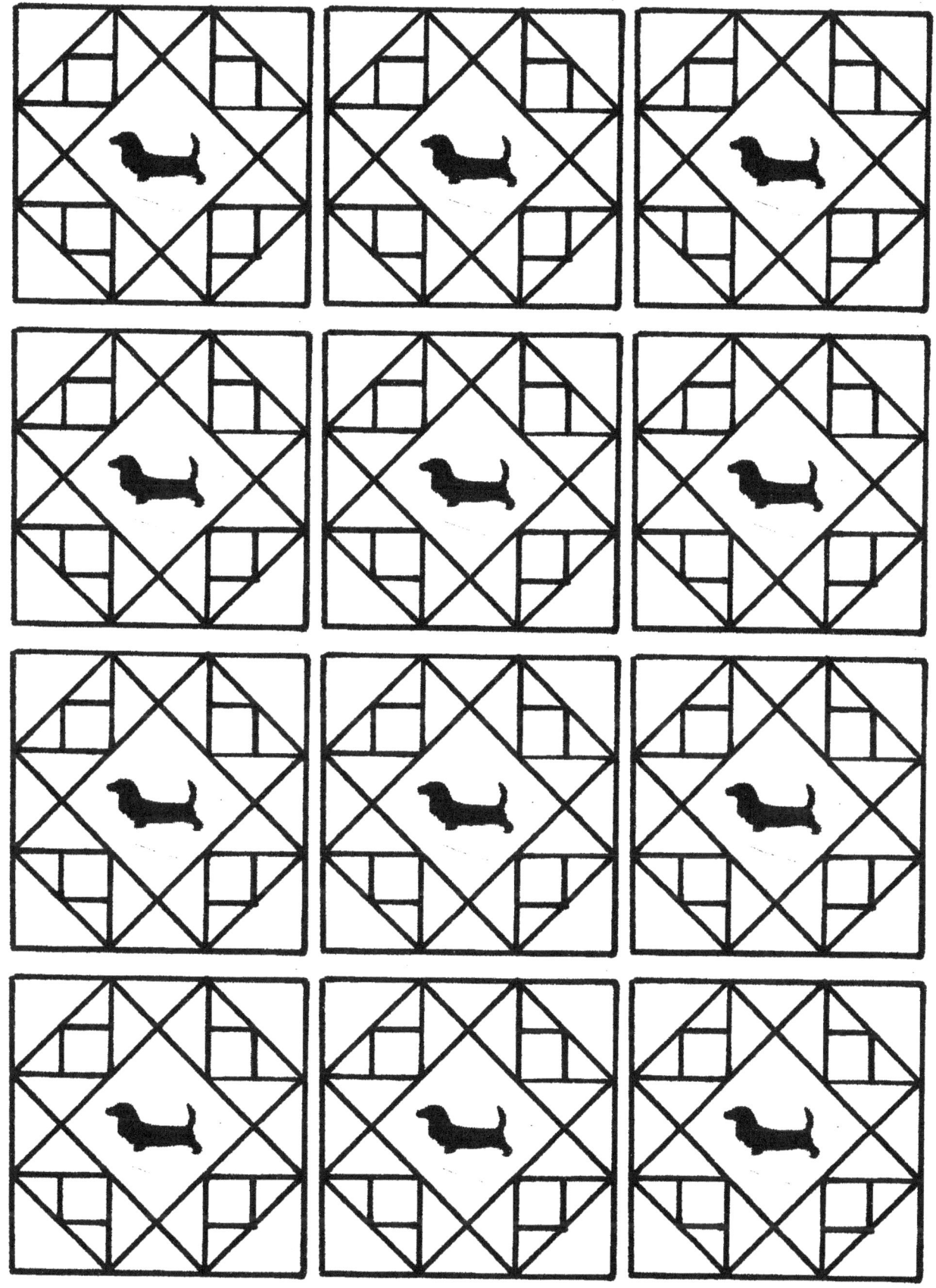

Barn Quilt Martha Washington Star
Franklin County Vermont

Barn Quilt Location
Guilmette Rd
Richford, Vermont

Franklin Barn Quilt Martha Washington

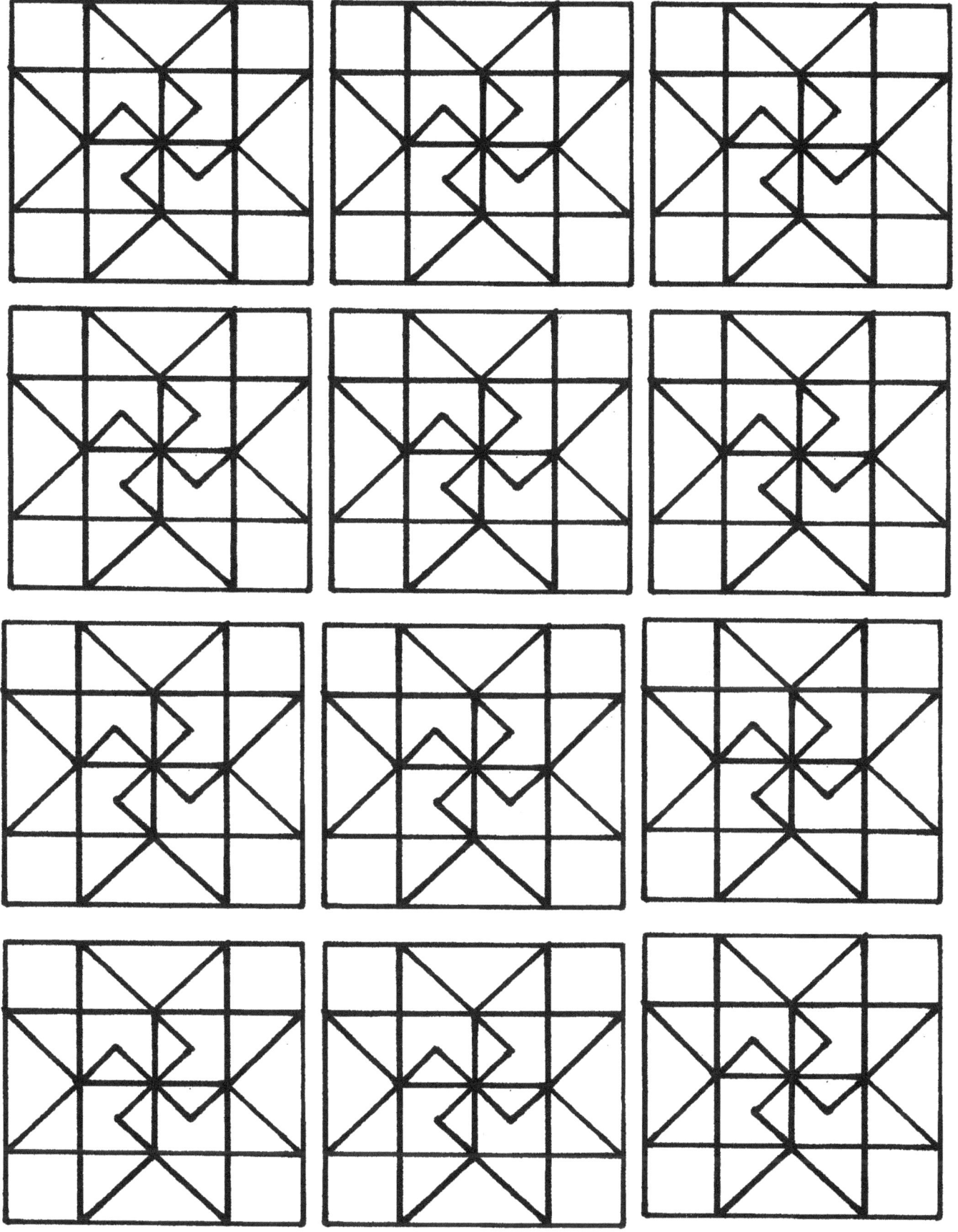

Barn Quilt Ribbon Cross
Franklin County Vermont

Barn Quilt Location
Liberty St Ext
Richford, Vermont

Franklin Barn Quilt Ribbon Cross

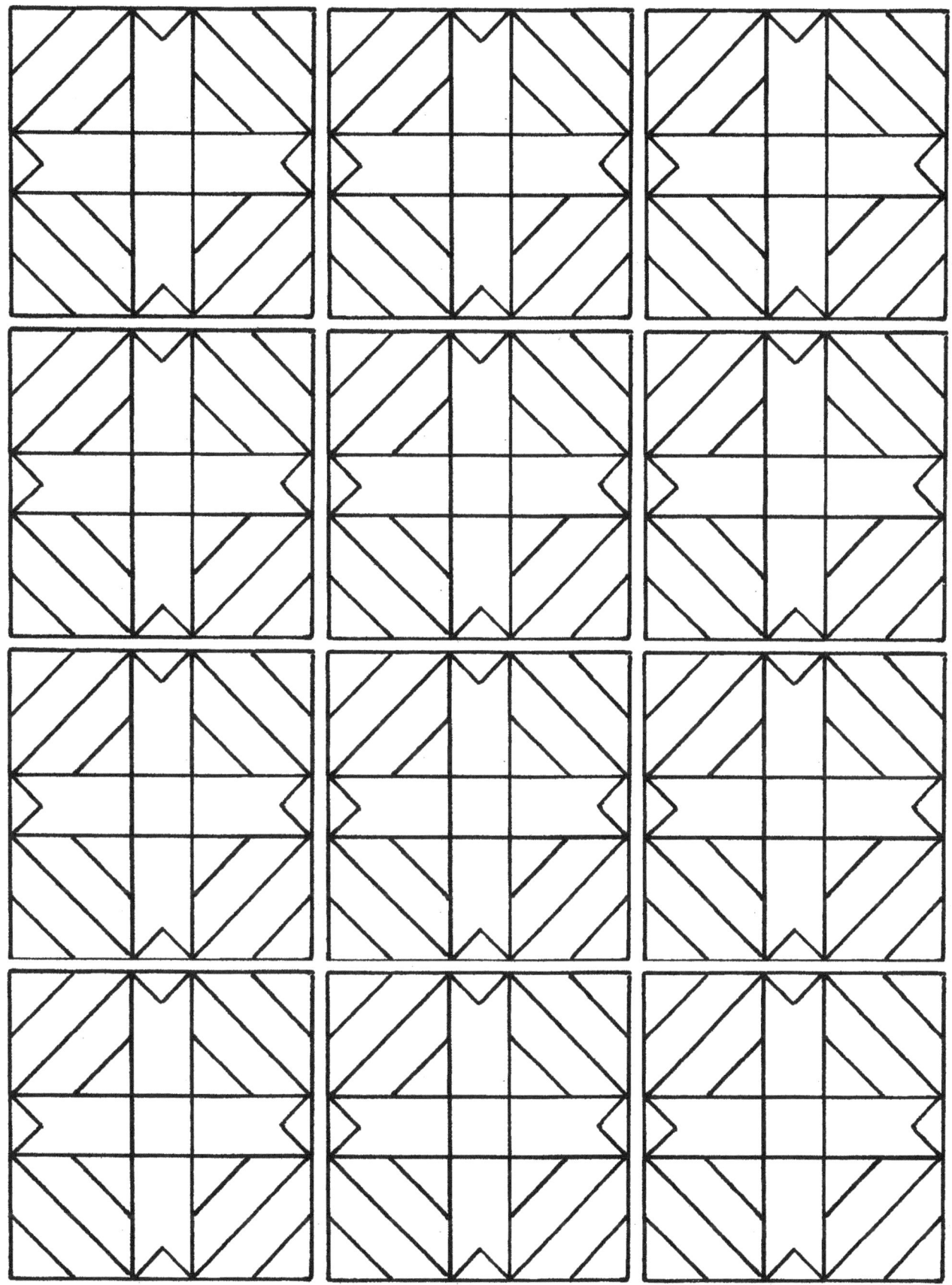

Barn Quilt Star Burst
Franklin County Vermont

Barn Quilt Location
East Sheldon St
Sheldon, Vermont

Franklin Barn Quilt Star Burst

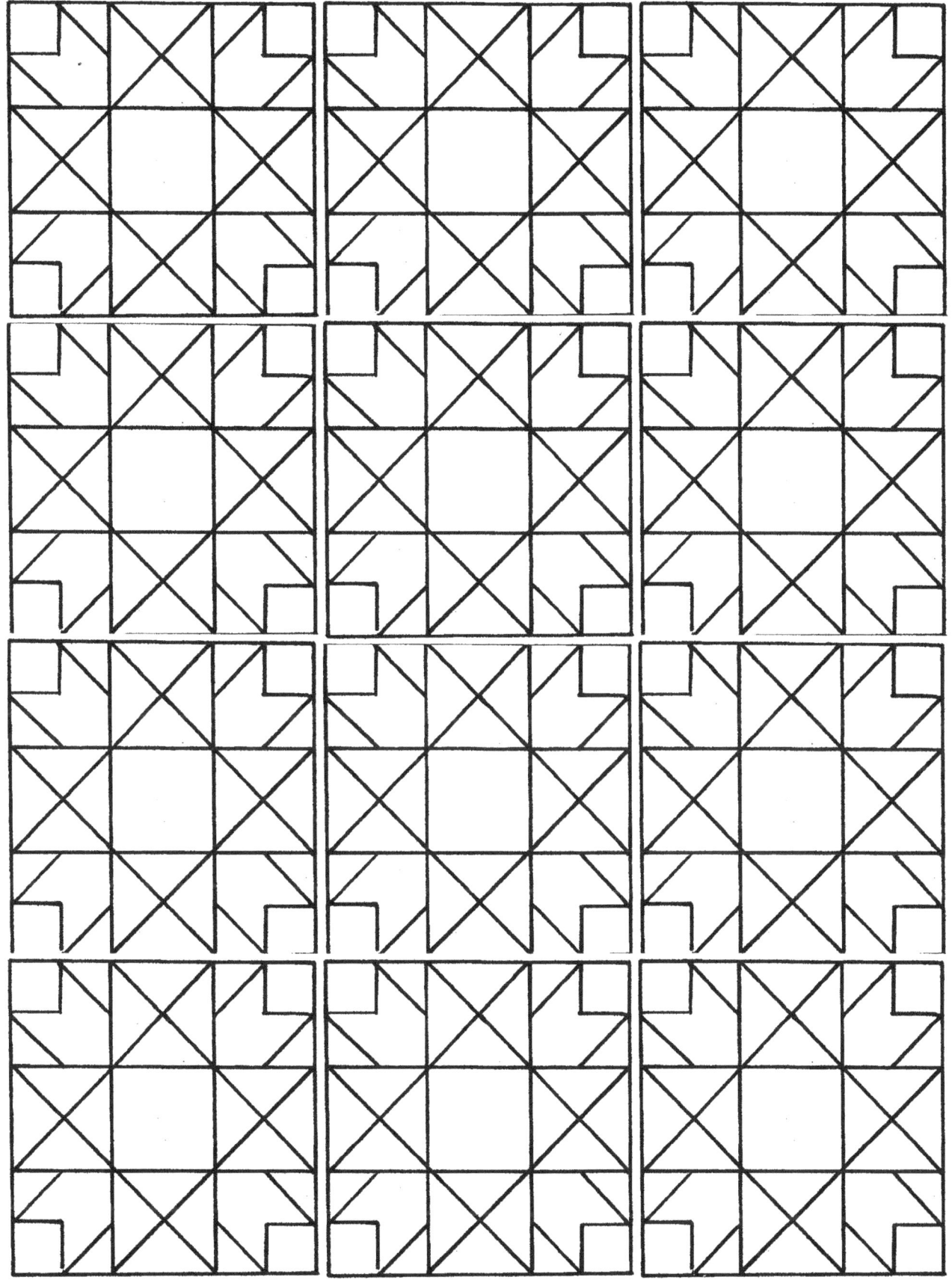

Barn Quilt Paddle
Franklin County Vermont

Barn Quilt Location
Patton Shore
Franklin, Vermont

Franklin Barn Quilt Paddle

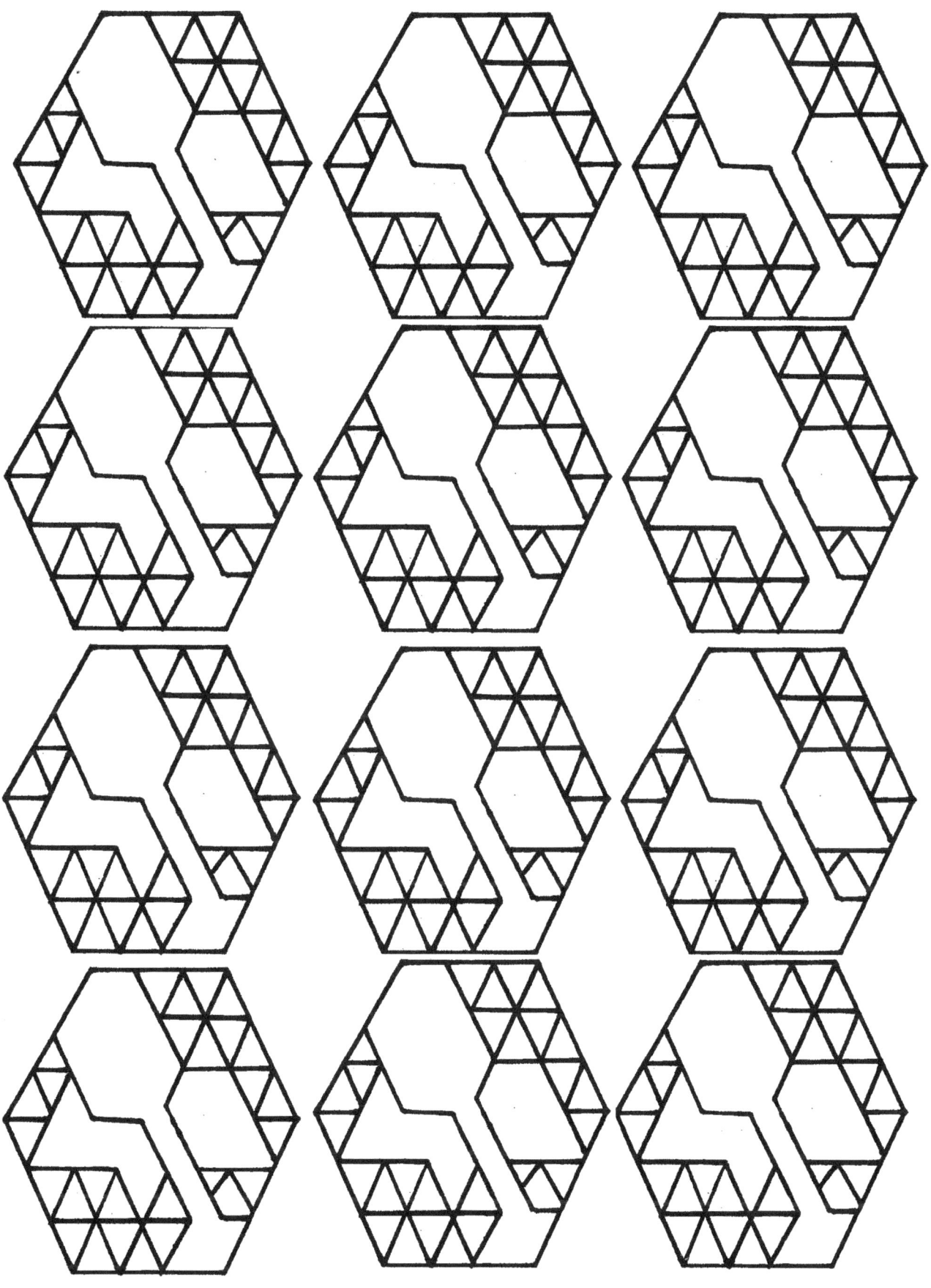

Barn Quilt Eight Pointed Star
Franklin County Vermont

Barn Quilt Location
Casino Rd
Sheldon, Vermont

Franklin Barn Quilt Eight Pointed Star

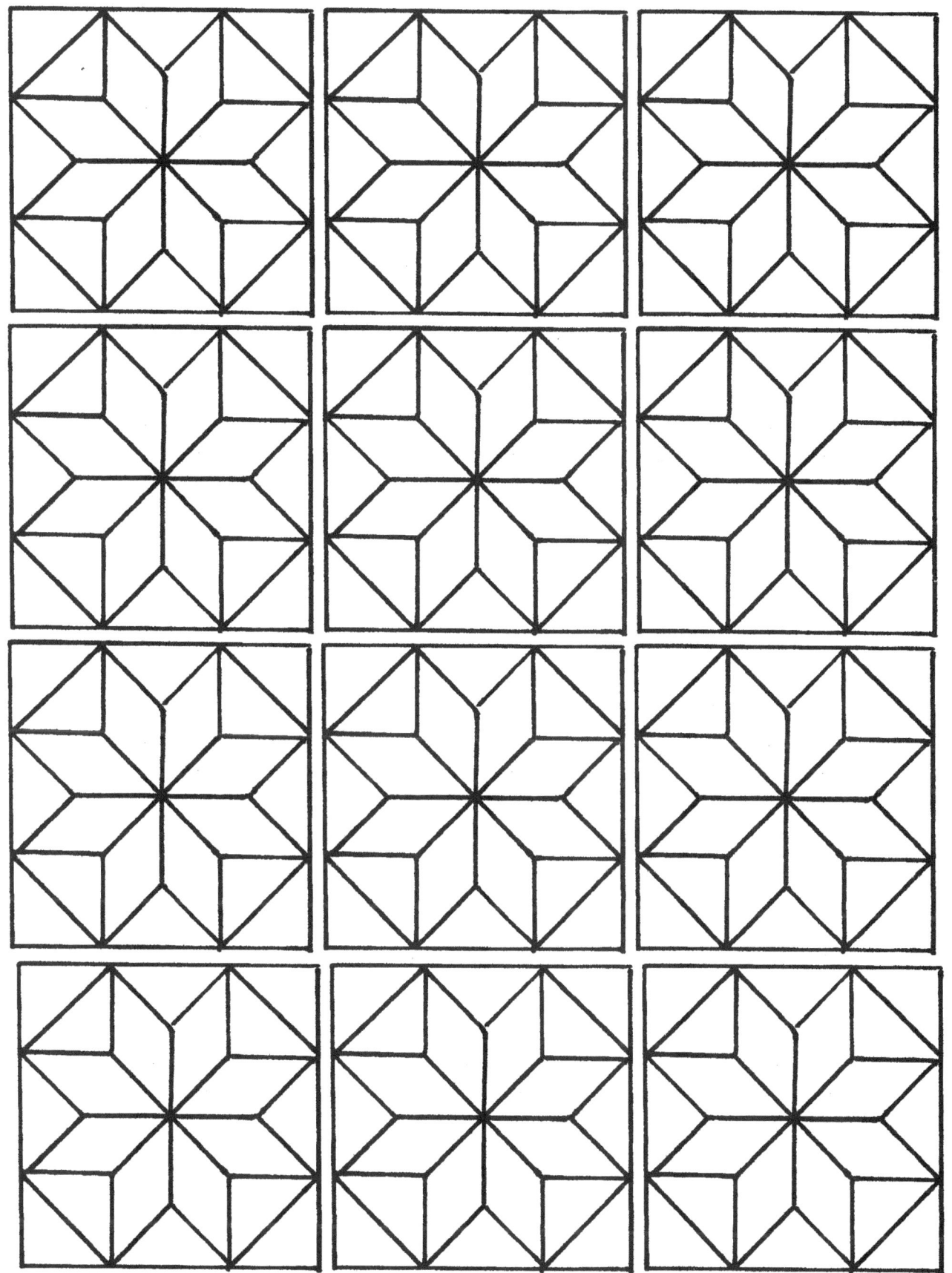

Barn Quilt Basket
Franklin County Vermont

**Barn Quilt Location
Lost Nation Rd
Berkshire, Vermont**

Franklin Barn Quilt Basket

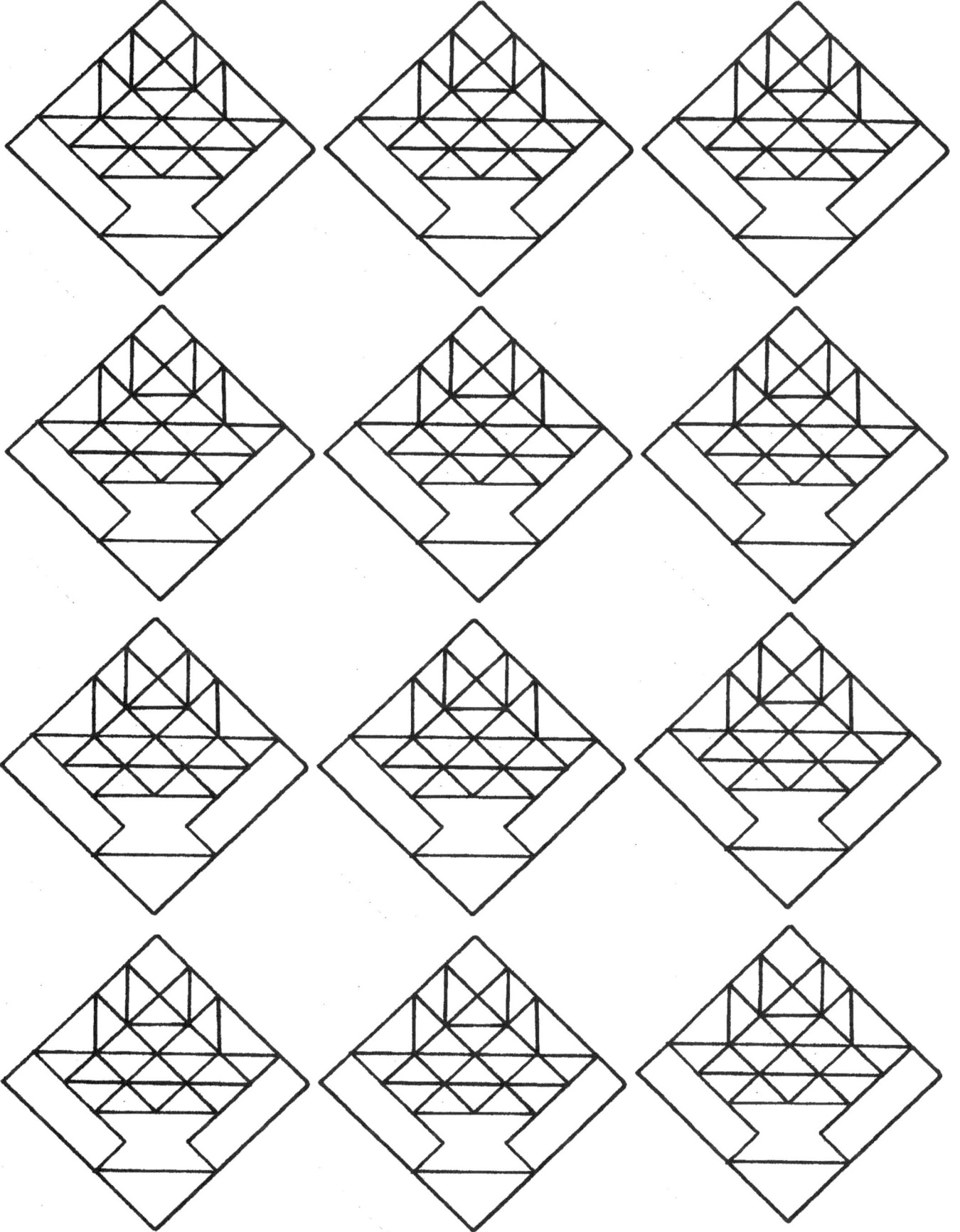

Barn Quilt Kansas Star
Franklin County Vermont

Barn Quilt Location
Middle Rd
Franklin, Vermont

Franklin Barn Quilt Kansas Star

John Lettau Coloring Books

Barn Quilt Coloring Books

Shawano County Wisconsin Barn Quilt Coloring Book One
Shawano County Wisconsin Barn Quilt Coloring Book Two
Delaware County Iowa Barn Quilt Coloring Book
Franklin County Vermont Barn Quilt Coloring Book

New Barn Quilt Coloring Books Coming Soon

Green County Wisconsin Barn Quilt Coloring Book
Tennessee Appalachian Barn Quilt Trail Coloring Book One
Tennessee Appalachian Barn Quilt Trail Coloring Book Two

Geometric Patterns

Geometric Design Coloring Book One
Geometric Design Coloring Book Two
Geometric Design Coloring Book Three
Geometric Design Coloring Book Four
Geometric Design Coloring Book Five

Graph Paper Designs

Create Your Own Geometric Quilt Patterns With Graph Paper Designs

Coloring Books Help Relieve Tension & Stress Plus it's Fun

Order...John H. Lettau at Amazon.com

READING & MATH BOOKS by JOHN H. LETTAU

1st Dimension	Grades 3-6
2nd Dimension	Grades 3-6
Primary Dimension	Grades 1-4
Aztec Math Primary Book One	Grades 1-3
Aztec Math Primary Book Two	Grades 1-3
Aztec Math Intermediate Book One	Grades 3-6
Aztec Math Intermediate Book Two	Grades 3-6
Aztec Math Jr. High Book One	Grades 5-8
Aztec Math Jr. High Book Two	Grades 5-8
Aztec Math Decimal Book	Grades 4-8
Aztec Math Fraction Book	Grades 4-8
Sum-Action Number Puzzle Book One	Grades 3-6
Sum-Action Number Puzzle Book Two	Grades 3-6
Sum-Action Number Puzzle Primary Book One	Grades 1-3
Sum-Action Number Puzzle Primary Book Two	Grades 1-3
Multiplication Number Puzzles	Grades 3-6
Geometric Design Puzzle Book One	Grades 3-6
Geometric Design Puzzle Book Two	Grades 3-6
Aztec Reading Primary Book One	Grades 1-3
Aztec Reading Primary Book Two	Grades 1-3
Math in Action	Grades 3-6
A-Maze-ing Number Puzzles	Grades 3-6
Graph Paper Designs	Grades 2-6
Pick-A-Dilly Papers	Grades 3-6
Awards for All Reasons	Grades 1-6
Time Marches On	Grades 1-3
Pennies, Nickels & Dimes	Grades 1-3
Super-Sum Activity Cards	Grades 3-6
Learning Center Game Boards	Grades 1-3
Aztec Design Coloring Book	Grades 1-6

www.ingramcontent.com/pod-product-compliance
Lightning Source LLC
Chambersburg PA
CBHW080712190526
45169CB00006B/2345